The Painter's Corner

WATER EFFECTS

BARRON'S

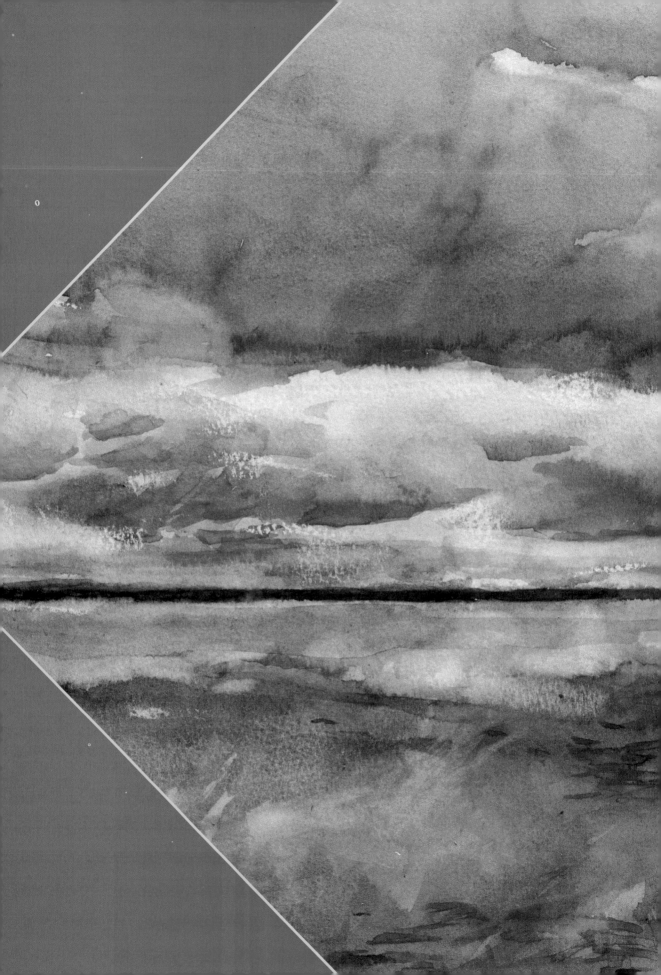

WATER
EFFECTS

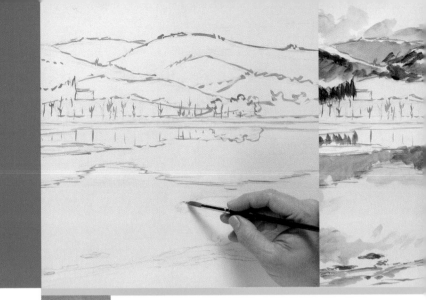

Original title of the book in Spanish: *El rincón del pintor: Agua*
© Copyright Parramón Ediciones, S.A., 2004—
World Rights
Published by Parramón Ediciones, S.A., Barcelona, Spain
© Copyright of authorized reproductions, VEGAP, Barcelona, 2004

Authors: Parramón's Editorial Team
Text and Coordination: David Sanmiguel
Exercises: Vicenç Ballestar, Carlant, Myriam Ferrón, Mercedes Gaspar, Óscar Sanchís, David Sanmiguel, and Josep Torres
Book Design: Josep Guasch
Photographs: Nos & Soto, Mercedes Gaspar, Gabriel Martín, Esther Rodríguez, and Óscar Sanchís

Translation by Michael Brunelle and Beatriz Cortabarria

International Standard Book No. 0-7641-5709-4

Library of Congress Catalog Card No. 2003106930

Printed in Spain
9 8 7 6 5 4 3 2 1

Table of Contents

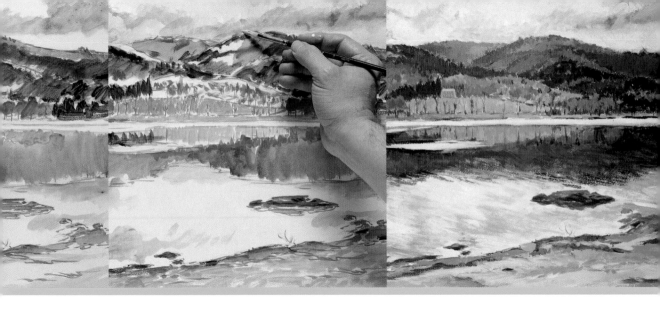

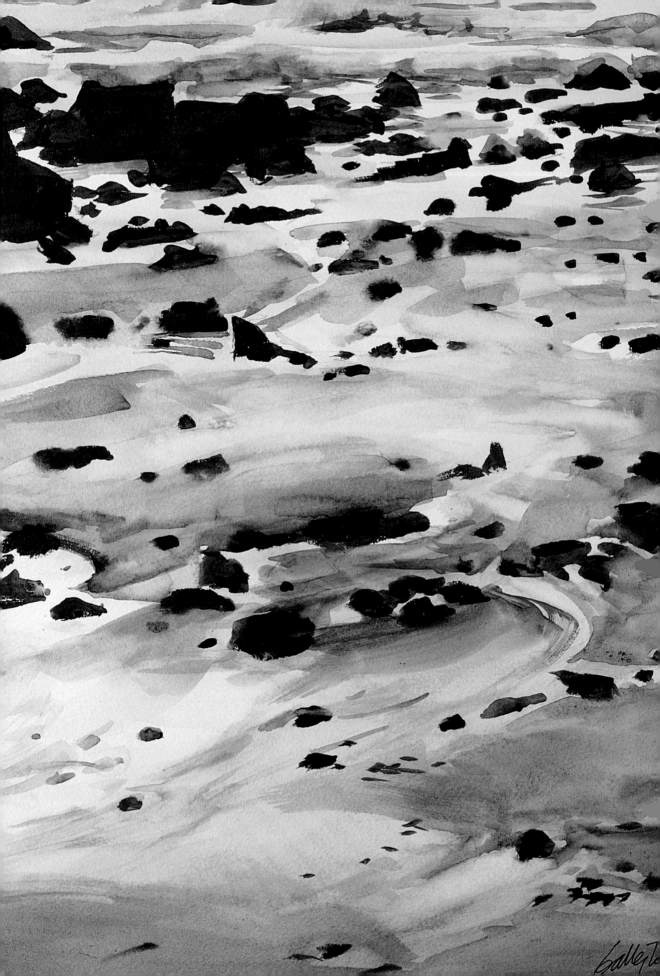

Introduction

No other aspect of a landscape is as changing or as fluid as water. Water has neither shape nor color. How can the artist represent something that has no specific form or exact color? This book has been conceived and created to respond to that question. And the answers are many, one for each day of the year, almost one for each hour of the day, because water does have shape and color, but they fluctuate so much that the artist must make a conscious effort to concentrate so as not to get lost in the ever-changing flow of colors and highlights. To all of this, we must add the conditions dictated by each medium, its scope and limitations. Watercolors can represent the flow of the waves masterfully, but oil paints go far beyond in subtly expressing the deep colors. Pastels have the ability to create the atmospheric colors over the ocean at specific times of the day, and so forth. Each medium is a creative path for expressing the light and color of seascapes, of landscapes with rivers and lakes, and of any other theme where water is the protagonist. This book explains and provides step-by-step examples for walking those paths successfully.

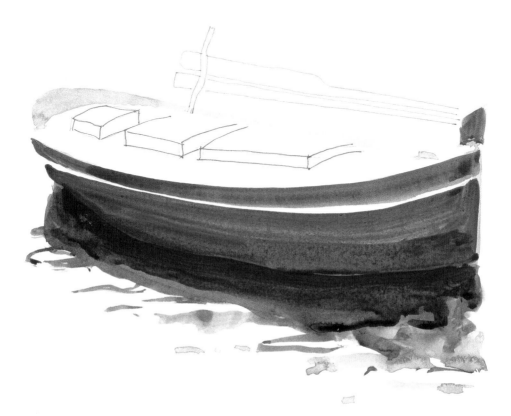

Water in Painting

Water has always been a recurrent theme in Eastern art. But in Europe, this subject had to wait for the development of the landscape genre for painters to seriously consider the many artistic possibilities of water.

The representation of water has been inevitably tied to the tradition of landscapes, and in the Western part of the world, landscapes did not make their appearance until quite late. Little is known about the landscapes that the ancient Greek and Roman civilizations could have painted. Almost certainly they followed the traditions flourishing at the time, with masterpieces as rich as the sculptures they produced, but nothing or very little has been preserved. No landscapes were produced in the Middle Ages, but in the fifteenth century they begin to emerge in the background of the religious scenes painted by Italian and Flemish artists.

◆

Water, as an element of landscapes, has increasingly captured the attention of successive generations of artists.

◆

From that moment on, the evolution of landscapes has been the story of an emancipation that was not fully realized until almost four hundred years later with the arrival of Romanticism. Water, as the main element of landscapes, has increasingly captured the attention of successive generations of artists, from those for whom seascapes were only a strip of water in the background of a landscape, to those who devoted their entire time and effort to painting the water reflections of a pond. This chapter reviews that story and shows a few of the most important masterpieces that echo that evolution.

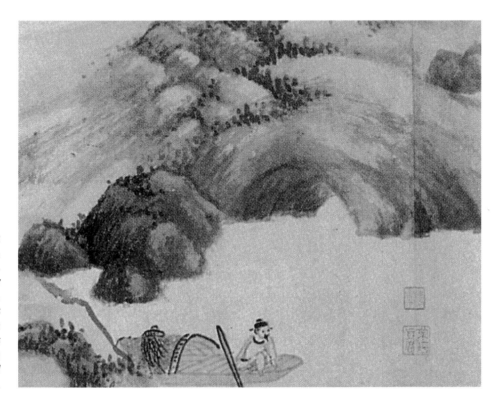

Wu Zhen (1280–1354), Fishermen (detail). Freer Gallery (Washington, D.C.). Chinese artists were specialists in seascapes centuries before European painters attempted this theme.

Water in Painting

In Western art, seascapes made their appearance alongside landscapes. The detailed backgrounds of fifteenth-century Flemish paintings used to include landscapes, and it was not unusual to find the sea depicted in the distance. In these paintings, the relevance of the sea was secondary, not only with respect to the main theme but even in relation to the landscape in the background. In the next century, these landscape backgrounds acquired a certain independence from the main themes, and as a consequence, the representation of the sea became much more visible, although it always formed part of a larger scenario that comprised mountains, valleys, cities, and a vast extension of land. The water of the rivers, lakes, and oceans was one more element in a magnificent natural setting that attempted to include it all.

INVENTING THE HORIZON
The Renaissance painters were the first to use perspective, a technique for representing space in which the horizon line plays a crucial part. In interior spaces the horizon line is implied, but in landscapes it is clearly visible. This is especially true in seascapes, where the horizon divides the background in two. In this sense, the development of marine painting is inseparably linked to a new vision of the world, and to a new vision of painting.

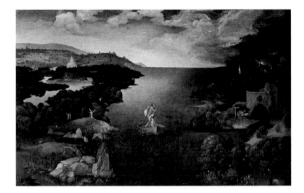

Joachim Patinir (1485–1524), The Lagoon at Styx and Caron. *Museo del Prado (Madrid, Spain). The obvious presence of the horizon line determines the allegorical character of this painting in which the sea is the imposing element as much from the representational standpoint as from the symbolic.*

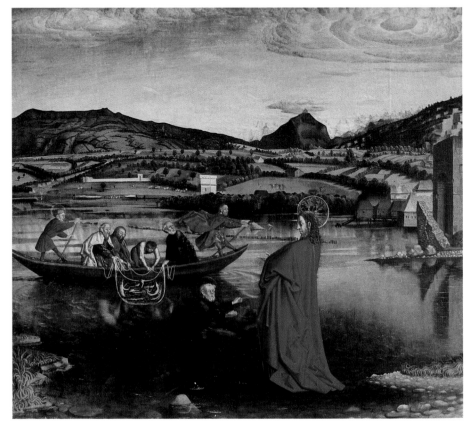

Konrad Witz (1400–1445), The Miracle of the Fish. *Musée d'Art et d'Histoire (Geneva, Switzerland). One of the first examples representing water in Western painting. The lake depicted in this work corresponds to a real lake and shows great observation skills of the artist working in a tradition that is completely foreign to landscape painting. The highlights, reflections, and soft ripples in the water are treated with great naturalism.*

Large Seascapes

The representation of the sea as the sole landscape element appears in large paintings of naval battles (or of ships run aground) painted in Holland in the seventeenth century. Painting seascapes then still required justification, and artists painted the sea as the background for another theme. However, the dynamism of the waves, the effects of light, and the highlights are less dramatic or spectacular. Something different takes place in the inland scenes: Dutch landscapes looked completely modern, and there is no shortage of landscapes with water scenes that are very similar to themes painted by artists today.

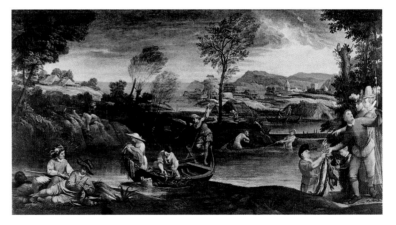

Annibale Caraci (1560–1609), Landscape with a Fishing Scene. *Musée du Louvre (Paris). Beyond the figurative narrative, the quality of this landscape, where the water plays a main role exceptional for this period, is outstanding.*

Jacob van Ruisdael (1628–1682), The Banks of a River. *National Gallery of Scotland (Edinburgh). Ruisdael was the first great modern landscape painter. In addition to introducing the vision of the landscape as an artistic theme in its own right, this painting depicts water as a vital element of the theme.*

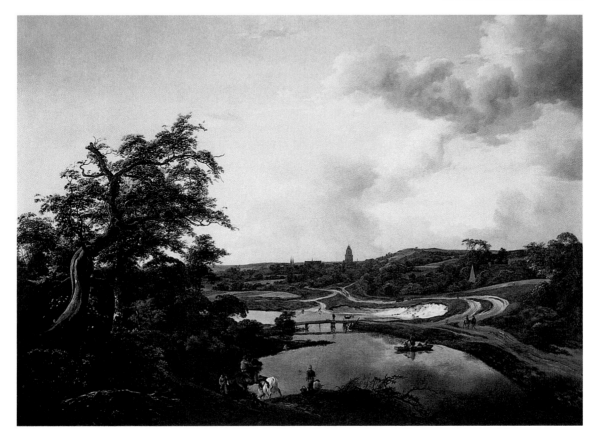

The Views of Claude Lorrain

Claude Lorrain, also known as Claude de Lorraine (1600–1682), is the most significant figure of the classic landscape, a "studio" landscape, calculated to the most minute detail to give a version of nature that is harmoniously constructed and idealized. Some of the most famous scenes are those of harbors in the evening light. The effect has great evocative power and suggests a true romantic feeling (although Romantic landscapes per se will not make their appearance for more than a hundred years). The delicate effect of crepuscular light on the surface of the sea is a discovery of great transcendence, widely used by many different artists through the history of seascapes and paintings of water in general.

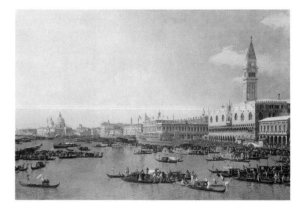

Antonio Canaletto (1697–1768), Pier at Saint Mark's on the Day of the Ascension. *National Gallery (London). Great mastery in the treatment of water is expected from an artist who specialized in painting Venetian scenes. Canaletto was truly a consummate master in resolving the effects of the water, which were characterized by a personal combination of meticulous and careful observation and free artistic license.*

Claude Lorrain (1600–1682), Port with the Embarkation of the Queen of Sheba. *National Gallery (London). Paintings of evening scenes by Claude Lorrain became famous in his time, and this artist was widely imitated. The classicist inspiration of his paintings gives way to a romantic vision of the marine spectacle, introducing a new style for approaching the theme.*

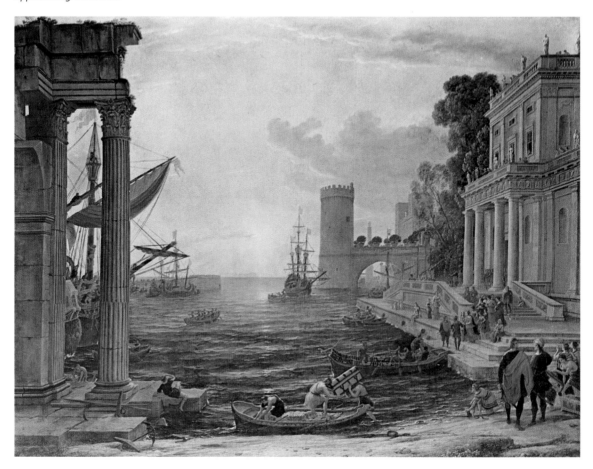

The Canals of Venice

In the Venice of the first half of the eighteenth century, a particular school of landscape painters developed who specialized in the representation of the city and its canals. These paintings sold very well. They were purchased by the nobility or by wealthy people, English for the most part, who were visiting the city. Because water is an inescapable reality of Venice, these paintings formed a body of work that cast great influence on the development of the genre. Artists such as Canaletto and Guardi were the key proponents of all the urban scenes depicting water from the rivers or canals.

Théodore Géricault (1791–1824), Heroic Landscape. *Neue Pinakothek (Munich, Germany). The presence of water in the landscape has been used by this artist to create an atmosphere of twilight mystery. The river is depicted as a smooth and hard surface like metal.*

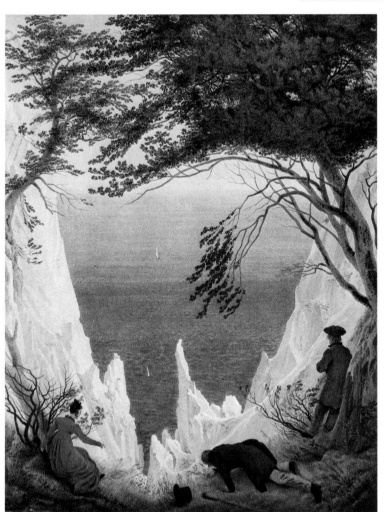

ROMANTIC LANDSCAPES
The overall acceptance of the landscape as an artistic genre took place at the end of the eighteenth century, and coincided with a new approach to nature. This consisted of a markedly sentimental vision based on the idea that the representation of landscapes could express a person's state of mind.

It is from that vision that artists, in their desire for personal expression, searched for landscape opportunities that were exceptional for their violence (such as storms and avalanches), or for their ecstatic calmness (such as winter or evening sunsets).

Caspar David Friedrich (1774–1840), The White Cliffs at Rügen. *Private collection. One of the most famous paintings of the Romantic period, this painting defines the new spirit that moved artists to paint seascapes: the contemplation of the subliminal spectacle offered by nature.*

Turner

William Turner (1775–1851) was the great genius of Romantic landscapes. His innovations and his vision of landscapes approached those in the Impressionist style, preceding the latter by several decades. His paintings of storms, foggy mornings, and fiery red sunsets are spectacular. With Turner, water always creates unexpected results of superb quality, be it a Venetian lake (a recurrent theme in his body of work), the banks of a river, the sunset over the ocean, or a wind and rain storm. Water was always a source of artistic surprises, with techniques that at times remind us of abstract art. Since Turner, many artists have looked at landscapes with a different eye, searching for different highlights or for surprising reflections.

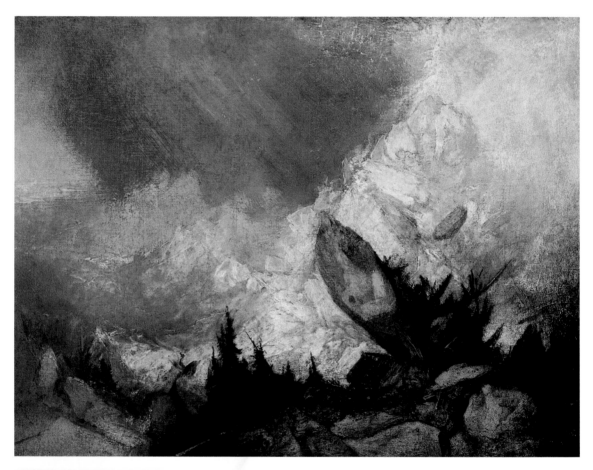

William Turner (1775–1851), The Avalanche. *Tate Gallery (London). Romantic landscape painters felt a special attraction to the violent effects unleashed by nature. This ice and snow avalanche develops a theme that is extraordinarily romantic and atypical in landscape painting.*

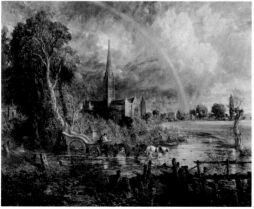

John Constable (1776–1837), The Cathedral at Salisbury. *National Gallery (London). Constable, together with Turner, is the great innovator of modern landscape painting in anything related to the Romantic conception of nature. Water is the absolute protagonist here, as much in the geography of the landscape as in its atmosphere.*

The English Watercolorists

The strength of landscapes as the favorite genre of the English, combined with the acceptance of watercolors among artists, gave way at the beginning of the nineteenth century to the birth of landscape painting with watercolors. After overcoming the resistance of academic biases that dictated the supremacy of oil paintings, watercolor landscapes became popular among professional and amateur artists all over the world. Among the work by great British Romantic watercolorists (such as Sandby, Bonington, and Constable), the paintings that depict water stand out perhaps because of a certain secret affinity between the theme and the medium that these painters were able to capture and create in their paintings.

WATER PAINTED WITH WATER
Watercolor is a medium that seems to have been created for painting landscapes. The subtle transparency of the tones evokes the atmospheric mist of humid places, the delicate nature of the color is ideal for painting fog and clouds, and the splashes of color often look like a direct reference to the movement of river or sea water. For many landscape artists nothing is more appropriate than watercolors for painting the water in a landscape.

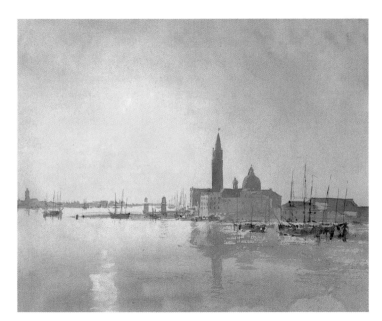

William Turner (1775–1851), Venice, Saint George the Greater Seen from Customs. *British Museum (London). Without even looking for the surprising effect of light, Turner has achieved spectacular luminosity in this watercolor, created with a simple technique that has maximum expressive impact. The water is represented with a mere few brush strokes over an overall wash.*

John Varley (1778–1842), York. *British Museum (London). Following the lead of watercolorists such as Varley, still water became one of the favorite themes for those who practiced these techniques. Even today, many watercolor artists continue to paint this type of scene.*

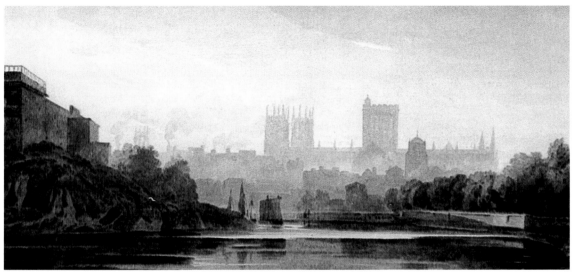

The Eastern Style

Landscapes were a recurrent theme in Chinese paintings many centuries before they first appeared in Western art. Many Chinese landscape paintings that have been preserved date back to the seventh century, about eight hundred years before European painters began considering landscapes as a true art form. Eastern artists understand landscapes very differently from the characteristic Western approach. The techniques that the former use have not changed very much through time, and one cannot speak of an evolution of styles in the European sense of the word. The formula, however, is purely landscape-like: a descending perspective that articulates a monumental panorama, in which water is always present, whether in the form of a river, a current, or a cascade.

Edward Savage (1761–1817), Waterfalls at Passaic. *The Worcester Art Museum Collection (Worcester, Massachusetts).*

THE INFLUENCE OF EASTERN LANDSCAPES
The influence of Far Eastern art reached Western artists in the eighteenth century. Some of them practiced the delicate Chinese approach to representing water. In the wash illustrated on this page, the artist has drawn the shapes with the tip of the brush and a minimum of materials, leaving the paper white to depict the presence of water.

Wu Zhen (1280–1354), Fishermen (fragment). Freer Gallery (Washington, D.C.). In this amazing painting, the white paper represents the water of the river: the artist has suggested its surface in the composition by contrasting full areas and empty areas. This level of sophistication is characteristic of Eastern art.

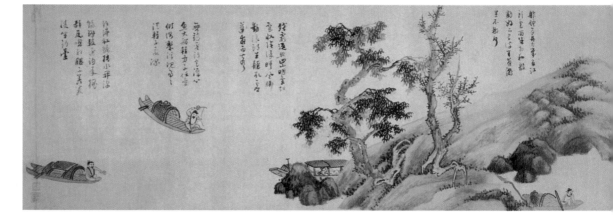

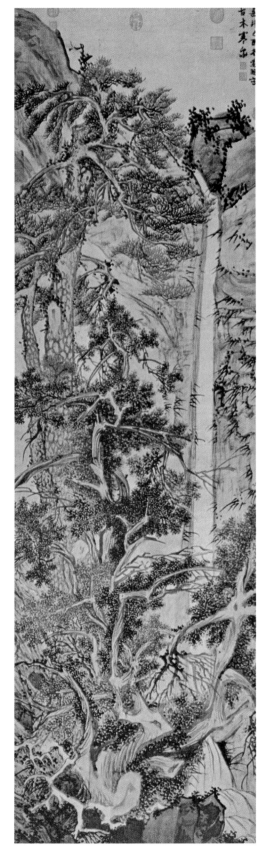

The Influence of the Japanese Print

Eastern art has been admired by European artists since the eighteenth century, but it did not really affect the way they worked until the Impressionists incorporated Japanese forms into their landscape paintings. These forms mainly originated from the Japanese prints that could be purchased in Paris for an affordable price in the second half of the nineteenth century. The most famous artist of such prints was Hokusai, creator of very well-known landscapes. It is almost certain that any art enthusiast who tries to remember a landscape with rain or with a wave remembers him. Hokusai, more than any other Eastern artist, was the creator of the most famous landscapes with water in history.

GRAPHIC EXPRESSION
Eastern landscape paintings have a graphic quality that is rarely achieved by their Western counterparts. Even in such ever-changing themes such as water surfaces or currents, Chinese artists found a graphic approach rather than a plastic one that was admirable for its simplicity.

Wang Shizen (1634–1711), Swallow's Reef in Nanjing. *Museum für Kunsthandwerk (Frankfurt, Germany). The simple and direct way of representing the waves is based on a simple graphic approach that evokes the surface of the water very effectively.*

Wen Tcheng-ming (sixteenth century), Pine Trees and Cypresses in the Waterfall. *The Palace Collections (Taipei, Taiwan). The fantasy of the drawing is dictated by the naturalistic representation of the landscape in which the falling water defines the format as well as the composition.*

Impressionism

The landscapes that are painted nowadays by the majority of professionals and enthusiasts are influenced by Impressionism. In its most basic sense, Impressionism implies freedom of choice in the selection of themes, and therefore in choosing the most cherished and loved subjects. Although this may seem obvious now, it was not the case at all during most of the art periods. Impressionist painters freed themselves from academic mandates and the restrictions of noble genres and themes. With the Impressionists, landscape painting went through a great historical revolution, and seascapes and water paintings in general occupied a place of honor. Claude Monet (1840–1926) was the great patriarch (and also the inventor) of Impressionism. He spent his last years painting the pond in his garden in the French city of Giverny over and over again, creating masterpieces that for many are the best of his long artistic career.

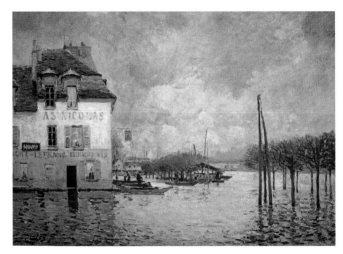

Alfred Sisley (1839–1899), The Flood of Port Marly.
Musée d'Orsay (Paris).
The water and its reflections are a theme that is especially favored by Impressionist artists. The movement of the light is represented with small, broken brush strokes.

IMPRESSION, SUNRISE

This is the title of what it is believed to be the first Impressionist painting. Its creator, Claude Monet, painted it in 1874 and it was not well received by the critics, who called it impressionistic—that is, not very concrete. Curiously enough, it is a theme in which water stands out in a way that seems perfectly logical today but that was unacceptable then. The water and the sky share the same exact color, without any artificial distinctions between them; the visual sensation perceived in the moment is what counts.

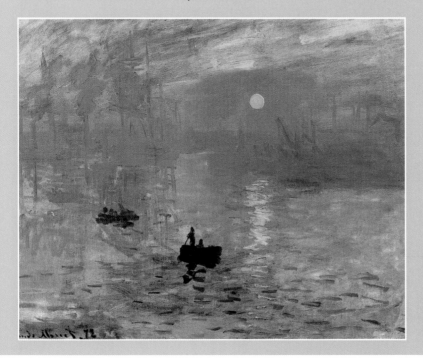

Claude Monet (1840–1926), Impression, Sunrise. *Musée Marmottan (Paris). The title of this painting gave the name to a new trend: Impressionism. This work sets the aesthetic and technical principles of landscape painting.*

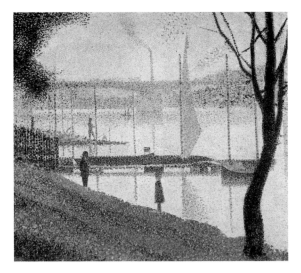

The New Chromatic Freedom

One of the most problematic restrictions of academic painting was a rule dictating that artists should use a very limited color palette, in which the dominant color was an assortment of grays. For a landscape artist with realist ideas this meant the abandonment of reality in the representation of landscapes. After breaking with these restrictions, the Impressionists opened the doors to a fresh and truly sensitive view of the outside world. The public was able to see for the first time that the ocean could be gray or ochre or deep green. The color of water was broken up into a prism of multicolor reflections, and the atmosphere of the landscape became a full-fledged part of the painting.

Georges Seurat (1859–1891), Bridge at Courbevoie. *Courtauld Institute (London). Pointillism is a variation of the Impressionist method. The pointillist artist Seurat felt a deep attraction for expressing the water surface and for the solemn effect of the reflections on it.*

John Twatchtman (1853–1902), The Waterfall. *IBM Collection (Armonk, New York). Fauvism and Symbolism are extreme expressions of Impressionism. The forms and the water that runs through them break up into an outburst of spreading brush strokes of exploding color.*

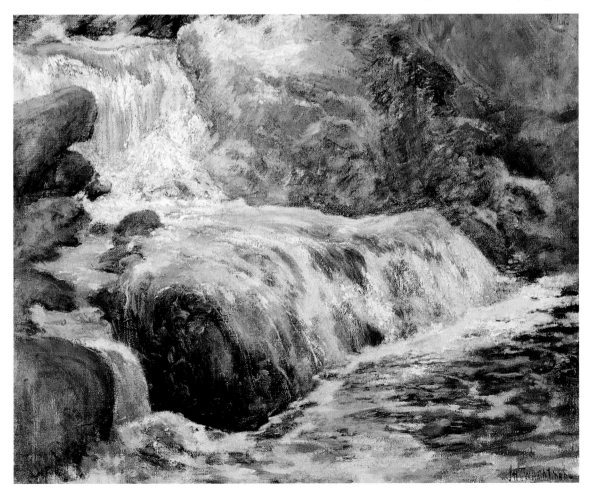

The Evolution of a Genre

Most landscape artists nowadays are, to a greater or lesser degree, followers of the Impressionist movement and of seascapes, and the modern themes with water derive to a certain extent from the work of those masters. Curiously enough, it turns out that even those who practice abstract art acknowledge the influence that the work of Monet has had on them, specifically his famous series of the *Waterlilies*. In Monet's work, the surface of the water becomes an evanescent mirror that partially reflects the surrounding elements and partially reveals the bottom of the pond. This ambiguity, so characteristic of water, has attracted the attention of many painters eager to find new solutions and sensations and freedom in the enjoyment of landscapes. Therefore, it would not be an overstatement to say that water, as far as art is concerned, is at the forefront of artistic sensitivities.

THE MEDIUM AS PROTAGONIST
The brush stroke that describes a highlight or a ripple in the water becomes a valuable calligraphic symbol in the hands of some abstract painters. In their work, even though the figurative references are missing, it is inevitable to think of the gentle or violent fluctuations of a body of water.

Luis Felipe Noé (b. 1933), Missionary's Meditation. *Private collection. This is a free interpretation of a landscape, in which the water is suggested, rather than represented, by the large area of mauve color in the lower right half of the composition.*

David Hockney (b. 1937), Figure Sunbathing. *Private collection. This graphic representation of the water vividly contrasts with our idea of art, and offers a very contemporary approach to traditional landscape painting.*

Keys to Representing Water

The masses of water present a particular problem that cannot be approached with the general concepts that apply to landscape painting. This chapter explains and illustrates the basic factors that guide the representation of water themes.

The most obvious problem involving the artistic representation of water is that it has neither shape nor color. With painting being the art of form and color, this presents a considerable inconvenience. However, it is important to remember that, in principle, water does have form, which is dictated by its surface. It can have one particular shape (a lake with still water) or many (a stormy sea). Also, water reflects the colors around it, and especially those above it (normally the color of the sky).

The reader will find explanations of the logic of reflections.

The representation of water implies the representation of reflections. In this watercolor by Mercedes Gaspar, the surface of the water produces a symmetrically inverted image of the sky.

Water consists of matter that is extraordinarily elusive; therefore, it is very important to know a few general rules before tackling it artistically. These rules are studied in detail in the following pages. In them, the reader will find, for example, an explanation of the logic of reflections on the water, the reason why this fluid appears darker when viewed from above than at eye level, and also why the objects reflected on it look darker. The answers to questions like these and many others that the artist no doubt will encounter when observing the ocean, lakes, and rivers with attention will not only satisfy his or her curiosity, but also allow the artist to work with a complete understanding.

Reflections

An inescapable aspect of landscape painting where the water surface is the main protagonist is the objects near its banks (trees, buildings, rocks, grass) or any other elements on the surface (such as animals, boats, buoys, and swimmers). The most noticeable thing at first glance is that the objects appear inverted, that their shapes can be seen with either great clarity or distortion from the movement of the waves, and that their colors are more or less murky but always less intense than those of the real objects.

The reflections are always darker than the real objects because they reflect their lower parts, which have less exposure to sunlight.

From a high vantage point the reflections are even darker because the most visible parts are the least illuminated.

REFLECTIONS AND WAVES

Except on rare occasions, the reflections are seen constantly distorted by the motion of the waves. Knowing their logic can help represent the reflections under those conditions.

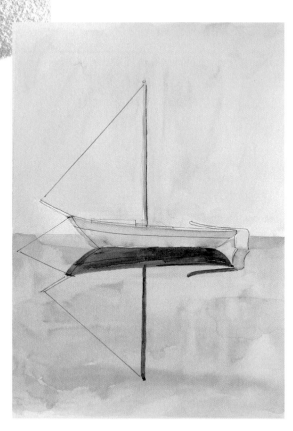

From a vantage point almost at water level, the reflections produce a symmetrically inverted shape of the objects, maintaining their exact dimensions.

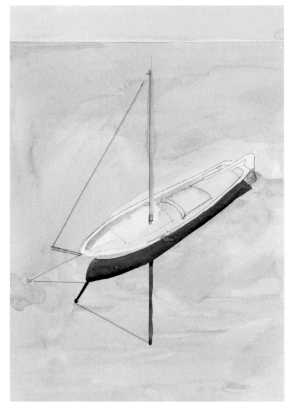

From a high vantage point, the reflections respond to an "angled" perspective and the size is reduced, as can be confirmed by comparing the length of the real mast with its reflection.

The Logic of Reflections

The principles that rule reflections on water are the same as those that rule the image of an object reflected in a mirror. An object set horizontally on top of a mirror appears inverted under its own base. The reflection duplicates the object's shape and size exactly. The perspective in a painting is the same for the landscape and for its reflection. They share the same vanishing points and lines because the real world and the reflected one share the same horizon. Therefore, the distance between the tip of a sail's mast and the water's surface will be equal to the distance between the surface and the tip of the reflected mast, as long as we look at the sailboat at eye level. If we raise our vantage point, the perspective will decrease the size of the reflected image, making it look smaller than the real object.

LIGHT IN REFLECTIONS
The objects in a landscape are always illuminated from above. The reflected images of those objects show their undersides (because they are inverted), which correspond to the side that receives less light. All of this means that in a landscape the reflected objects are always darker than the real ones, and they will appear even darker the higher our vantage point is with respect to the water plane.

Edward Hopper (1882–1967), First Branch of the White River. *Museum of Fine Arts (Boston). The reflections of the trees on the still waters of the river have a darker color as a result of the effect of the shadows' reflection.*

Still Water and Moving Water

Moving water has a definite effect on the reflections. The river currents deform the reflected shapes and turn them into a web of light and shadows, requiring the artist's mastery in handling the brushes in addition to his or her keen observation. The brush strokes should be quick and change from dark to light the farther away we go from the bank, while also becoming more distant from one another, more dispersed. The color changes as well. The tones closest to the light source should be lighter and more transparent than those at the riverbank. This task hinges on controlling the water in the mixtures and on the "touch" of the brush.

The still water of a lake acts as a mirror that reflects the contours and some details but not the exact colors (except on bright and sunny days); they are usually a duller gray tone.

No matter what the chosen theme is, there is no quick formula or method for painting the water. Rather it is important to observe the movement, the reflections, and the highlights produced by that movement.

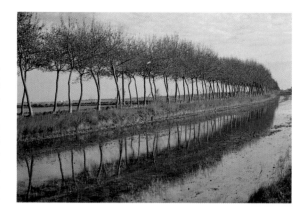

The reflections follow the same laws of perspective as the real objects. In this sketch, one can easily see how the trees and their reflections on the water have the same vanishing point.

The waves distort the shapes of the reflections, but it is those same reflections that make it possible to represent the undulation of the water, as illustrated by the simultaneous resolution of the reflections of the boat and the waves in this picture.

The Symmetry of Reflections

The rivers and lakes in a landscape are sources of a variety of reflections. The line of trees on the banks repeat their profiles, and the horizon beyond them can turn into an axis of symmetry that literally inverts the landscape. Many painters like to look for that axis in seascapes and lake scenes, selecting a vantage point that raises it or lowers it to the bottom part of the painting. If the bank is high, the foreground is dominated by the plane of the water's surface with all its combinations of highlights and transparencies. In such cases, the undulation and the gentle rippling become extremely important and can be excellent elements to enliven the composition. With rivers, the winding shapes can be used as a space-defining element similar to perspective.

Aureliano Beruete (1845–1912), The Manzanares River Under the French Bridge. *Private collection. The ripples in the water are represented through highlights and reflections, creating mixed coloration.*

John Twatchtman (1853–1902), Spring Morning. *Pittsburgh Museum of Art (Pittsburgh, Pennsylvania). Even though the sky could appear brightly reflected on the surface of the water, the reflections are always darker than the real objects.*

The reflections on still water are an exact inversion of the real objects, but their tone is always a little blurry (somewhat darker for the lighter colors and less contrasted for the darker ones).

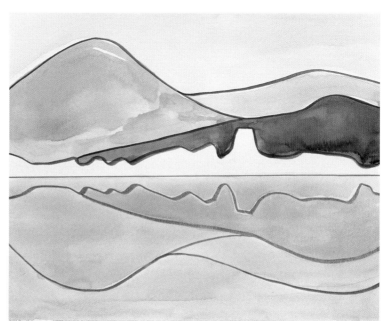

This landscape presents an ambiguity between the real shapes and the reflected ones. The smoothness of the water's surface makes it difficult to differentiate the real object from its reflection. Only the horizon line separates both.

The Tonalities of Reflections

The tone of the reflections is conditioned by the brightness of the day and by the reflected object. In this brief exercise we will see how a few dense clouds, which are bright on their upper part but dark below, are resolved. Inverting the reflection will make this lower area the most important feature on the water's surface.

1 The subject does not require a preliminary drawing; it is approached with just color. First, the sky is painted, emphasizing the darkness of the clouds in the foreground.

TECHNIQUES USED

◆ Applying reflections ◆

MATERIALS
- A variety of watercolors
- Round, thin sable brush and wide synthetic brush
- Medium-grain watercolor paper

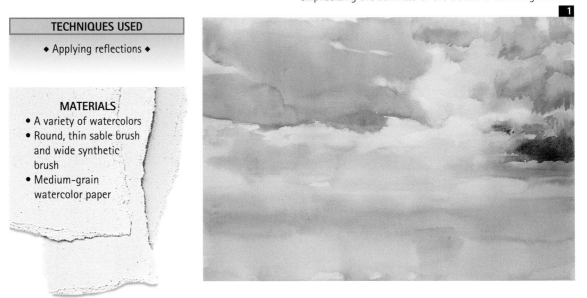

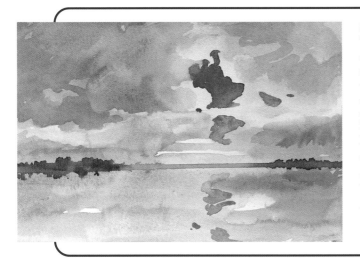

SPACE AND REFLECTIONS
The reflected duplicate of the real object emphasizes the perspective effect with more intensity, highlighting the feeling of space. The theme in this exercise produces a particularly powerful spatial effect caused by the progressive reduction of the size of the clouds and the contrast between the darker tones of the foreground and the lighter ones of the background. The previous step refers to this phenomenon.

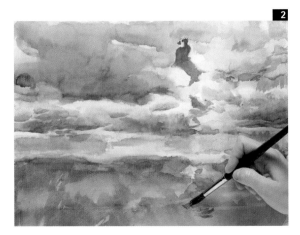

2 Next, a large dark area of color is applied on the lower part. It should not cover the entire surface of the water. A few areas should be left unpainted to represent the brighter parts of the sky.

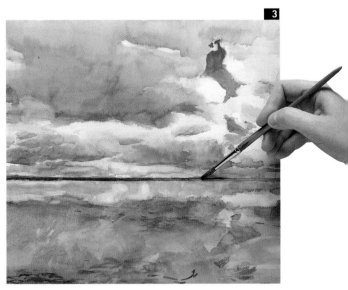

3 The horizon line is marked with a simple color line. This reference is sufficient to suggest the surface of the water on the lower part.

4 The result successfully captures the particular luminosity of the cloudy sky over the vast extension of the still water of the lake.

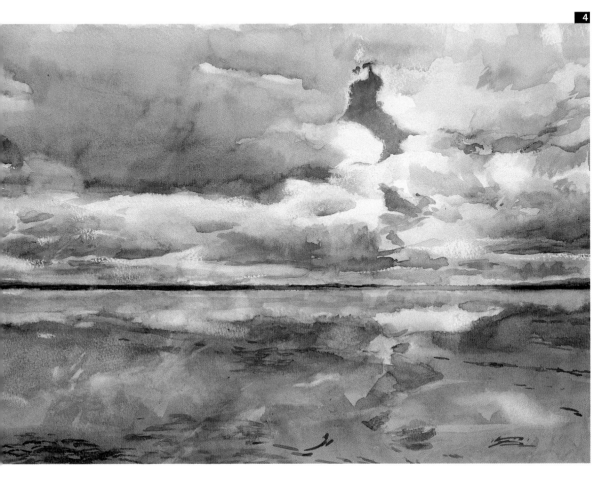

Resolving the Highlights

The highlights on the water can be the result of the sun setting low in the horizon (such is the case of the sunrise and the sunset), or the effect of shallow water. In the latter case, the sunlight is reflected almost entirely, creating a bright surface. This exercise is the result of such effect: a shallow river that flows through the trees in the forest.

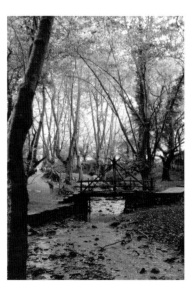

A river through the forest is a subject full of details and shadows that must be approached from the very beginning with great attention to the most basic elements.

MATERIALS
- An assortment of markers
- Hard graphite pencil
- Smooth drawing paper

1 The variety of lines and the complexity of the theme require a careful and exact drawing. But we will not dwell on this point because the purpose of the exercise is very different: to show the correct approach for applying highlights.

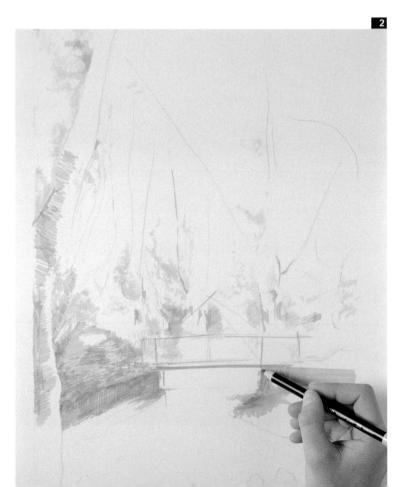

2 The work with the markers is methodical and slow: little by little the lines are drawn until an approximation of opaque colors and solid surfaces is achieved.

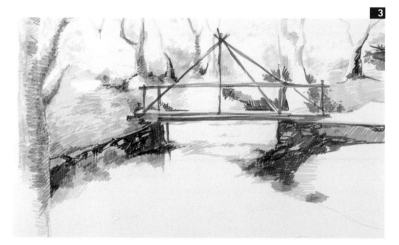

3 A white reserve is maintained for the river throughout the exercise, suggesting only a few dark reflections for the bridge and the banks.

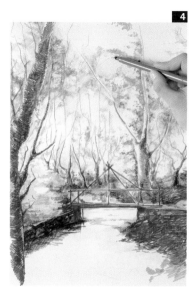

4 The deepest parts of the river begin to be filled with gray lines to suggest their different luminosity. In other areas, the thick forest of the landscape has been worked very carefully.

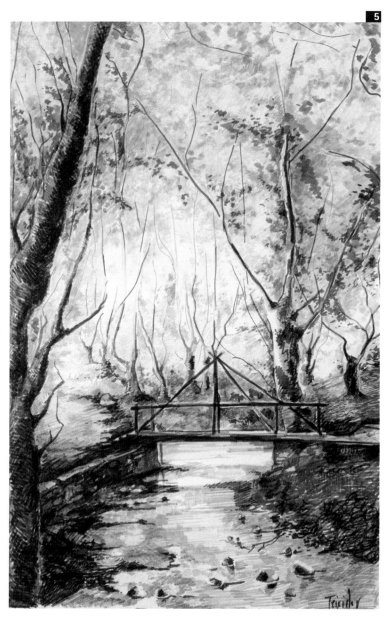

5 The parts of the paper left completely blank represent the highlights. Only a few green tones have been painted to evoke the green luminosity of this wooded landscape. Painted by Marta B. Teixidor.

Composition

In a composition everything is arranged according to the artist's own placement, that is, as a function of his or her point of view. In compositions with planes and structures, there is a geometric approach to the arrangement. The artist projects a series of simple straight and curved lines, which will dictate the parameters of the landscape: the foreground and other planes. There is always some element in the composition that suggests these lines: the beach, the shoreline, the riverbank, and so on. The relationship between different planes can also make reference to the lines of the composition. For example, the side of a mountain and the direction of the waves can be suggested with the same diagonal line. The reasoning behind this system for arranging the picture is to simplify the many approaches that can be used to express the coherence of the composition. Details can be added to these simple lines in an organized and clear fashion, instead of drawing them independently one by one.

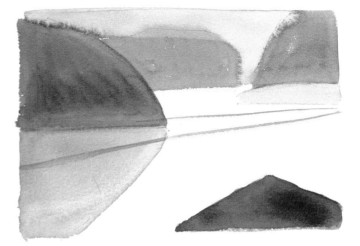

The painting below can be analyzed from the point of view of a diagram. The diagram can be similar to the one shown in the illustration at right. It demonstrates how both the spatial representation and the layout of the water's surface are based on a system of overlapping planes where their color intensity decreases the farther away they go toward the background of the composition.

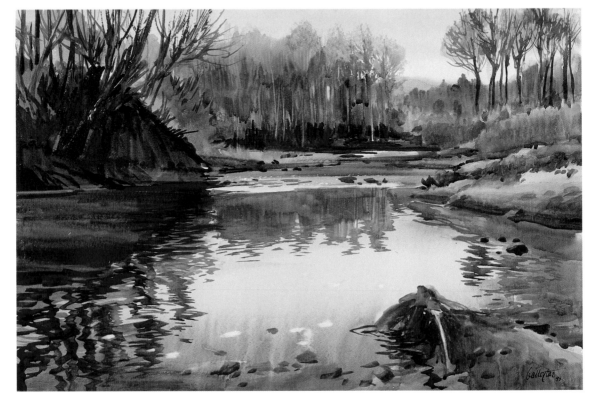

The Landscape Masses

There is a different type of composition that concentrates on the large masses in the landscape. The masses can belong to elements of the scene (the surface of the sea, the course of a river) or to large areas of light and shadow. Here the term *mass* is subjective and relates to the artist's visual perception. The sky can also be the mass in a landscape, creating great contrast with the color of the land or the sea. This phenomenon can be noticed when squinting at the landscape. By ignoring the definition of forms and the contours, what we see is the overall impression of the areas of light and shadow. A composition created through masses is "antigeometric." It does not respond to linear principles but to large areas of color in the landscape. A work created this way emerges from the contrast of a few light and dark areas that contain elements grouped according to the amount of light they receive.

SCHEMATIC COMPOSITION
Composing a seascape with planes or diagrams requires a linear approach to the theme. The artist paints the light and shadow and the individual elements in abstract form and tries to discover the basic lines that give structure to the composition. Obviously, the main element of a seascape is the horizon line because it separates the basic planes of sky and sea.

This sketch is an interpretation of a forested landscape with a stream running through it. In this case, the masses of the landscape contain more linear elements because the tree trunks form a dense network that fills the picture and gives it a sense of space.

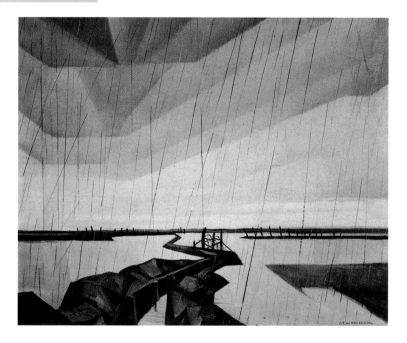

Christopher Nevison (1880–1946), Flooded Trench Near the Yser. The Imperial War Museum (London). In the styles influenced by Cubism, the emphasis on the structure of the painting forces the artist to represent the basic forms of the composition.

The Horizon Line

The horizon line is the key factor in the composition of a seascape—or of any landscape—because it determines its magnitude and vastness. We speak of the horizon line in the general sense of the word: It can be a horizontal element (as in the sea) or the irregular mountain range line in the background; the horizon can even disappear in the fog. However, it is always possible to determine a horizon line in a painted panoramic view.

A low horizon line also implies a low point of view when placed on the shore, almost flush with the water. A seascape with a low horizon line does not allow the inclusion of waves, or if they are painted, the sequence between them is very small. Very quickly we reach "the end," the background of the landscape. The great resource used by artists who like to paint low horizon lines is the sky, which can have large masses of clouds or a spectacular luminosity that greatly compensates for the limited interest of the sea, reduced to a narrow strip at the bottom of the painting.

The High Horizon Line

A high horizon line allows spreading the landscape almost over the entire surface of the support. It corresponds to a high point of view and an angled vantage point. The high horizon line promotes a descriptive style that favors the individualized representation of the features and irregularities of the terrain, the undulation of the water, and the expansion of the panoramic view to vast distances. Some artists raise the point of view until it almost touches the top edge of the support, or they even leave it out completely. The landscape then becomes somewhat reminiscent of a map and allows the artist to fill every nook and cranny of the painting with shapes and colors. The distances become shorter and the painting acquires a flat look, resembling a tapestry.

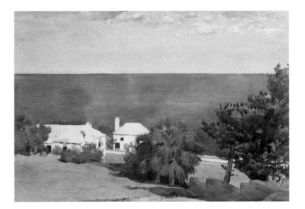

Winslow Homer (1836–1910), The Bermuda Shore. *The Brooklyn Museum (Brooklyn, New York). The definite and unequivocal presence of the horizon line is a reassuring factor in a painting. A horizon line like the one in this illustration renders the landscape into something totally static and solid.*

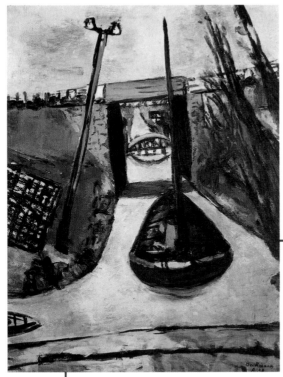

Max Beckmann (1884–1950). Canal in Holland. *Private collection. The inclination of the horizon suggests, in this case, the rocking of the boat.*

UNCONVENTIONAL HORIZON LINES
Some modern landscape painters have experimented with the compositional and spatial principles of this genre, distorting even the horizon line itself. From a theoretical point of view, the horizon should always be horizontal, and the inclination and sloping of the terrain must be independent from this fact. From a creative point of view, the horizon line can be slanted and distorted to create an unconventional space.

The results can be surprising because of the realism with which they convey the feeling of confusion and instability.

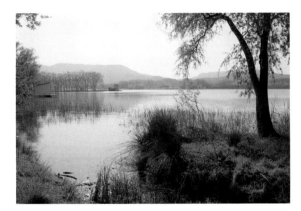

This lake can be interpreted in many ways (the tree in the foreground, the vegetation, etc.), but the most logical approach is for the artist to begin with the horizon line, which in this case coincides with the shore in the far distance.

1 From the beginning, the horizon line is the basic structural guideline of the painting, reinforced by the perpendicular line that is formed by the house, which together create a definite right angle.

2 All of the other aspects of the painting (reflections, highlights, waves, and so on) are developed from the basic structure dictated by the horizon line.

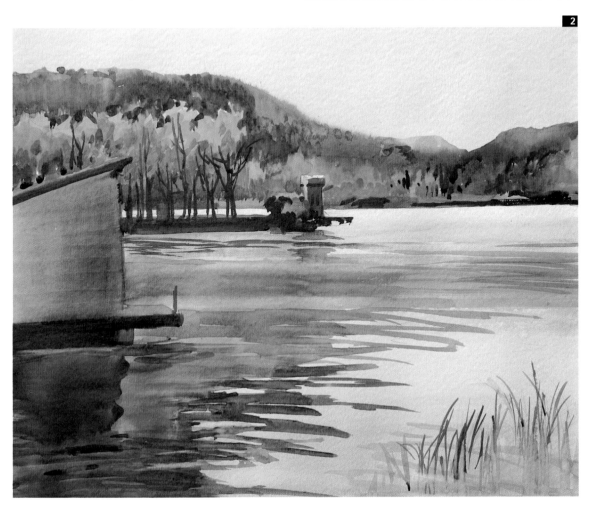

Blues

Conventionally, the water is blue, like the sky or as a result of it. But when the water is really blue, it is not the same color as the sky but different—or better said, made of many different blues. To create a good representation, besides observing the landscape carefully, artists must know the colors they have at their disposal and the best ways to use them. Ultramarine blue is the most common color on the palette of a landscape artist. The best results are achieved when it is combined with a small amount of white, mixed with carmine (to turn it more violet), or combined with burnt sienna (to make it grayer). Cobalt blue is the brightest of the blues, and its beautiful tone asks to be used without mixing. Other blues, such as cerulean blue, or the modern "phthalo" colors, are a little more aggressive and acidic, but they can be mixed with a little yellow to produce interesting turquoise colors. Prussian blue, not much used nowadays, muddies the mixtures quite a bit but produces very deep tones with a greenish tendency.

COLOR AND DEPTH
The color of the sea depends directly on the sunlight that it receives, but also on the depth of the water. Therefore, from the seashore it is normal to see sudden changes of color that range from light gray near the shore to a deep blue in the open sea (if it is a bright sunny day). In general, the blues are darker and more opaque in the deeper parts of the ocean—so much so, that in the open sea the blue can almost look like a black blue.

Auguste Renoir (1841–1919), The Seine at Asnieres. *National Gallery (London). The vivid contrast of the complementary colors between the boat and the water makes the effect of the blues look livelier.*

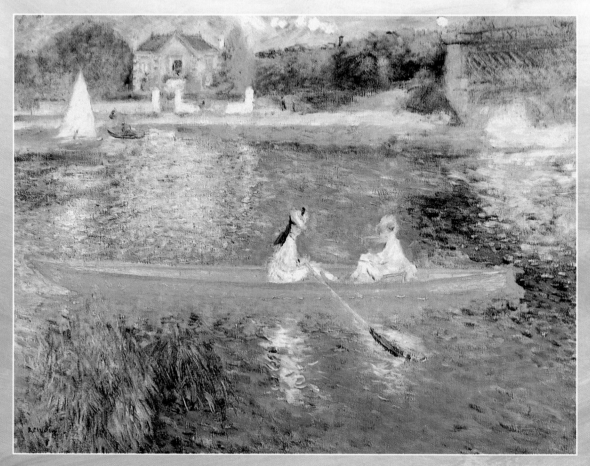

These are some of the blues that can be created by mixing ultramarine blue with white, a small amount of carmine, and a little bit of yellow, to make it more green. These colors are clean and luminous and can easily remind us of the sea under the intense summer light.

Mixtures and Color Ranges

Additional varieties of blue can be created by mixing them with carmine and yellow. The first color produces deep tones that look almost purple, whereas the second one (in small amounts) creates green tones. Blue mixed directly with green loses its intensity and becomes darker and more opaque. The range of blues is very wide, going from light tones that can look slightly green, to the deepest violet. Within this range, the sea calls for a variety of shades, like the different musical notes that belong to the same basic chord.

Édouard Manet (1832–1883), The Grand Canal, Venice. *Shelburne Museum (Shelburne, USA). The pure blues are bright colors that, applied with Impressionist techniques, produce beautiful artistic results.*

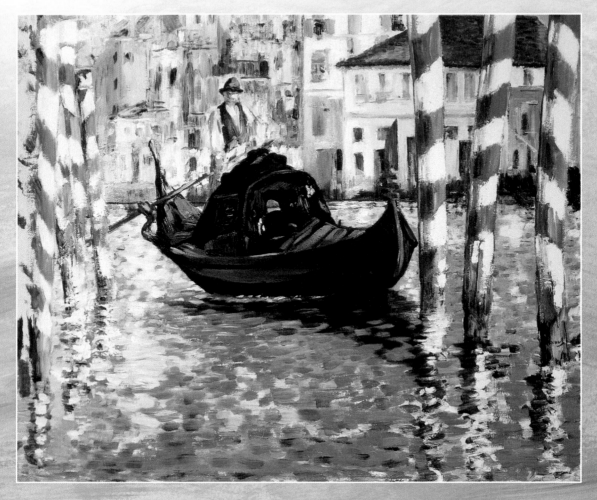

TURQUOISE AND EMERALD COLORS
What turquoise blue and emerald green have in common is that each is halfway between blue and green, and therefore, they are especially suitable for painting water. However, these colors are very bright and may appear unnatural when applied liberally. Used as secondary colors in an otherwise restrained background they can express the pristine and transparent qualities of water.

Greens

Whether in the sea, in a lake, or in a river, green is quickly associated with stagnant water or with its opposite, crystal clean water. And, in both cases, such water is recognized by its greenish color. But these two greens are very different. The green of stagnant water is opaque and ashen, whereas clean water has a completely transparent and luminous color. In the first case, we could say that the color is chromium green made lighter with white, or mixed with blue if the overall tone is cold and gray. In the second case it would be an emerald green created by mixing the color of the same name with a small amount of blue, making the mixture lighter with white. Chromium green, with its earthy tone, is the opposite of emerald green, which is much more appropriate for producing different shades when mixed with other colors.

Georges Seurat (1859–1891), End of the Jetty, Honfleur. *The Metropolitan Museum of Art (New York). This painting, of exquisite, delicate color, bases its effect on the green tones of the seawater.*

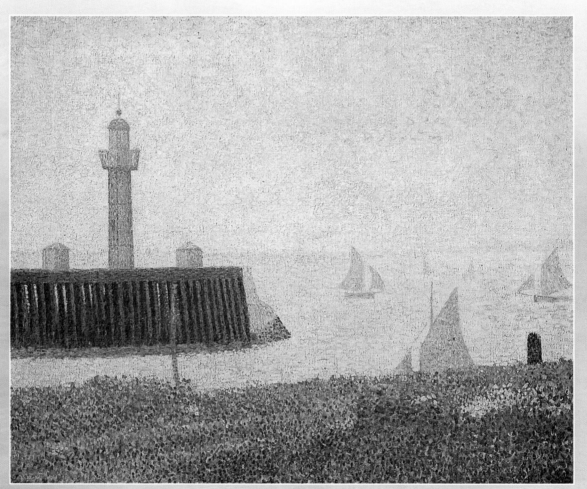

Greens According to Technique

Obtaining greens from mixing oil paints is not the same as making them from watercolors or pastels. The mixtures mentioned in the previous paragraph are more viable with oils. When using watercolors one cannot speak of mixing with white, but of more diluted colors. Also, transparent effects created with watercolor are guaranteed by their real transparency. As far as pastels (or color pencils) are concerned, one can talk about direct colors chosen from the extensive commercial varieties available, rather than mixtures. With pastels, as with color pencils, clean mixtures are not possible; instead, they have to be applied one color at a time.

Blue greens, emerald greens, turquoise, and the colors generally known as aqua green form one of the most luminous and attractive color combinations. They must be used with care to avoid artificial results.

Paul Cézanne (1839–1906), The Lake at Annecy. *Courtauld Institute (London). Greens show through among the blues, providing light and vitality to the combination of reflections on the water.*

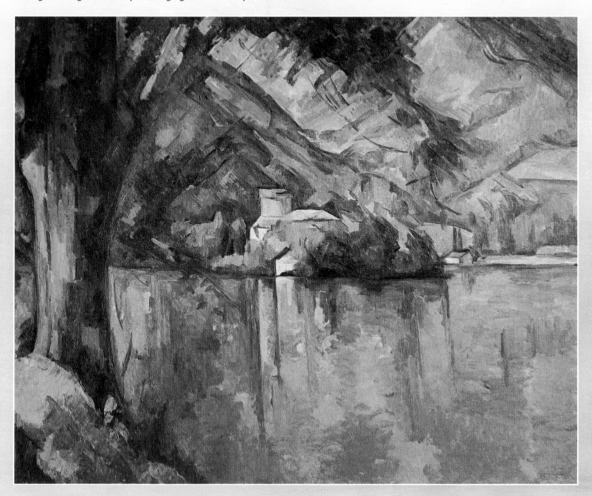

Browns, earth tones, siennas. These are some of the colors of water, especially in rivers and lakes.

Ochres

One of the most interesting color effects that water can present is the different ochre tones, golden or earthlike, produced by the luminosity of the sky, or by the mud carried by the river or present in a lake or in the sea. Under the sunset light, the earth tones acquire a golden luminosity that includes touches of green, yellow, and pink. If the waters are turbulent, the tones are usually more reddish and opaque, with hardly any highlights. The colors that correspond to these tonalities are ochre, raw sienna, and raw umber for the green tones, which can be the counterpart for the shadow. Ochre is intensified by mixing it with yellow, but this color is best used in moderation.

In general, when water presents an ochre coloration, it is usually a golden ochre tone resulting from the sun's reflection. To produce this color, white paint (or the white of the paper in the case of watercolors) must be used generously for the reflections, with a few touches of light green to create the appropriate golden effect.

Vincent van Gogh (1853–1890), View of Arles. Museum Thyssen Bornemisza (Madrid, Spain). A surprising orange ochre color dominates this sunset scene that gives the river a somber tone of earthy colors.

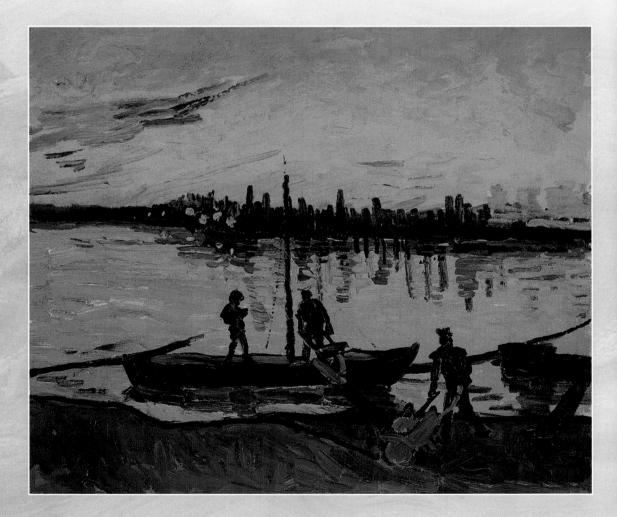

Neutral Colors

The earth tones that can be used to represent water usually belong to the group of neutral colors. These colors are characteristic for their "muddy" look, or their tendency to look gray. They are the result of mixing complementary colors and adding white. Yellow and violet, red and green, and blue and orange are all complementary colors. The result of mixing these pairs together is gray, which can have a blue, green, red, or different undertone, depending on the dominant color of the mixture. By adding white, the resulting color is a light gray tone that goes well with almost any other color.

WARM HARMONIOUS COLORS
It is unusual to find warm harmonious colors in seascapes, but the reflection of the light at sunset can create spectacular combinations whose dominant tones are oranges and ochres. The colors that go best with these tones are yellows and siennas. As with any palette, some contrast is necessary, and in this case, it is provided by cool colors. Grays or greens with a blue undertone can be the appropriate counterpart.

A painting with a surprising sepia coloration evokes the fury of a stormy sea. The light that comes through the thick clouds increases the menacing feeling.

Whites and Grays

White always requires a slight tinting, that is, to be lightly grayed with other colors, unless it plays a small part in the composition. Graying the white is a phenomenon that also occurs in a landscape with nature. A landscape with snow is rarely pristine white and without a smudge. But when this is the case, the snow creates a bright surface that is similar to the surface of the water when the sun is very low in the sky. The white snow is shaded and turns gray according to the conditions of the light and the characteristics of the landscape. The sea or a lake with light and soft colors contains a great number of grays. A very thin layer of snow leaves the mud and the grass visible. A large rolling field of snow reflects light, casts blue shadows, and has a variety of shades.

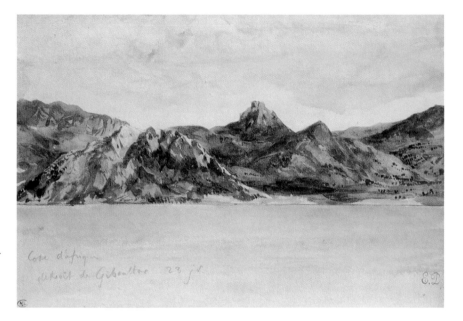

Eugène Delacroix (1798–1863), The African Shore. Musée du Louvre (Paris). The unexpected yellow-gray color of the water gives this watercolor painting chromatic originality.

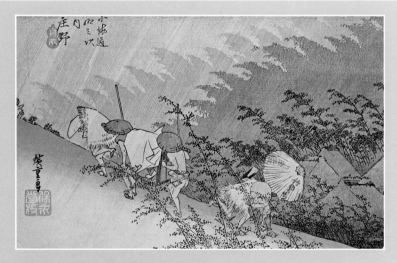

Hiroshige (1797–1858), The Shono Landscape. National Museum (Tokyo). A magnificent and rare example of a painting of rain. To depict the falling water, the artist has used fields or areas of color that gradually become lighter.

THE RAIN

A painting of rain is very unusual, but a few Eastern examples show how its representation is based on fields or areas of light colors, made softer the farther away they are from the foreground. In Eastern paintings, water is usually depicted through the effects it produces in the landscape (puddles, raindrops on water, etc.), and very rarely do artists paint drops falling, as is the case in some Japanese prints where the approach is more graphic than painterly.

Procedures for Representing Water

The only way an artist will be successful at depicting subjects involving water is by having an intimate knowledge of the possibilities offered by each technique.

Each painting technique produces a specific result when applied to subjects involving water. Each one separately is perfectly suitable for creating any scene, as long as the artist is realistic about the results that can be obtained with it. Many paintings are ruined when the wrong medium is used: watercolors that aspire to look like oil paints, or pastels that try to adopt the lightness of watercolors. The only way to avoid these errors is by knowing the properties and characteristics of the most commonly used media. That is the focus of this section of the book—to study the possibilities of the important procedures (the ones most widely used) for painting

◆

Many paintings are ruined when the wrong medium is used: watercolors that aspire to look like oil paints, or pastels that try to imitate watercolors.

◆

subjects that involve water scenes: pencil, pastels, watercolors, and oils.

Each one of these media forces the artist to approach the subject in a specific way, emphasizing some outstanding aspects and sacrificing others. Pencils, for example, are ideal for drawing, watercolors help create transparent effects, oils add a very rich element to all the color mixtures, and pastels produce harmonious results when creating areas of color. The following pages present this information in detail through examples and exercises.

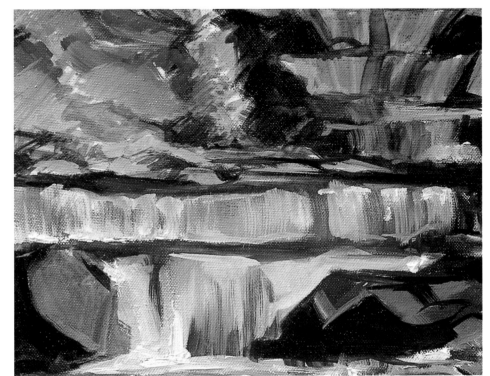

Even the most difficult-looking themes can be resolved easily if the artist adapts to the requirements of the media he or she is using.

Color Pencils

Pencils are the universal medium for sketching and for making quick studies outdoors. They are rarely used by landscape artists to create elaborate pieces, but if this is the case, they resort to color pencils, which are fast and effective and produce colors similar to the Impressionist palette. Compared with other drawing techniques, color pencils are ideal for small-scale work. Pencils are not suitable for large formats and produce better results when they are used for details, avoiding the involved techniques required by other methods.

Mixing Colors

Rather than mixing, with pencils we should be talking about superimposing colors, because actual mixing never completely takes place. Artists who draw with pencils always use a wide range of colors, precisely to avoid excessive mixing, but it is unusual to find a theme that does not require layering two colors to create a third one. The layering must follow a specific order: Light tones must be placed over dark ones. This is because light tones always have less covering power and the base color can then be seen through them, a necessary condition for creating the color desired. For example if red is applied over yellow, the resulting color will be that same red lightly tinted with orange. If, on the other hand, yellow is layered over red, the orange tone will be clearly visible.

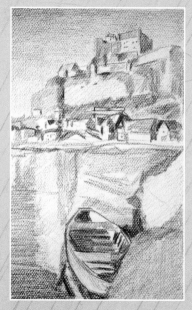

Color pencils follow the same principles required for drawing and shading as conventional pencils. The type of drawing and shading that we refer to can be seen in the illustration, which was done with blue pencil.

Color pencils go a step further in the elaboration of a drawing: Every tonal factor turns into a color value.

The degree of finish that can be achieved with color pencils is very high because of the precision and delicate impression of the lines.

BLENDING WITH GRAY OR WHITE

Color pencils have a property of their own, which has to do with their composition. That is their ability to blend lines by applying white or light gray over other colors. Their slightly waxy consistency may be more valuable than their small amount of coloring power in making it possible to blend lines together while barely affecting them with the white of gray tones.

Lines and Color

Drawing with color pencils is a lot like painting. The appearance of the color will depend on the type of line used. Light colors are created with hatching or by drawing lines with a certain amount of separation. In any case, lines should never cover the surface of the paper completely. Lines can be applied quickly, loosely, or with a controlled hand, drawn in the shape of a wheat tassel made with superimposed diagonal lines (appropriate when the artist wishes to create a consistent texture). Tones never look very saturated when drawn with pencils, although dense colors can be created by pressing the tip of the pencil hard against the paper.

A Lake with Color Pencils

This exercise shows the basic technique of coloring with pencils applied to a water theme that is particularly suited to this type of medium. The reader will be able to see how the line can be very valuable in the representation of the undulating motion of the water and resolution of its highlights and reflections.

MATERIALS
- A wide selection of color pencils
- Smooth drawing paper

The chosen theme is the view of a park from a lake. The most interesting aspect is the play of reflections and the changes in their shapes resulting from the ripples in the water and their proximity to the observer.

TECHNIQUES USED

◆ Drawing reflections ◆
◆ Use of the line ◆

1 The first approach is brief and consists of drawing the edge of the lake. From this point the vegetation is introduced with horizontal lines.

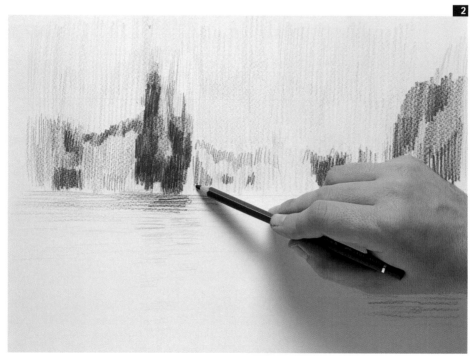

2 The green tones are alternated to create a series of lines, which will cause the color to get darker as they get denser.

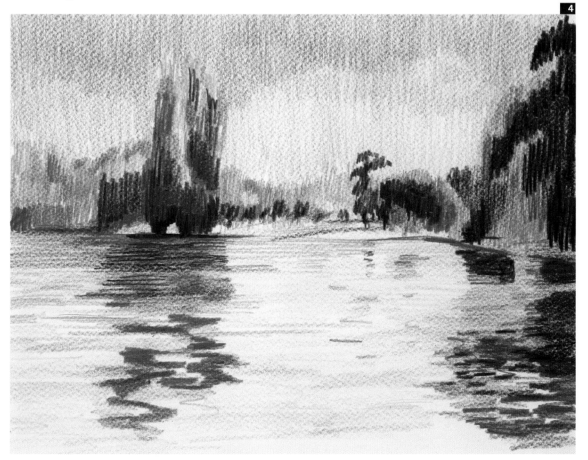

3 The undulation of the water is much more obvious in the foreground because that is where each small wave is clearly individualized.

4 The progressive accumulation of lines, which blends the line of trees at the shore with their reflections on the surface of the lake, has created an interesting overall effect.

Pastel Painting

Pastels are a direct medium, like color pencils, but much more painterly. They are not mixed on the palette, but instead are applied directly on the paper; therefore, a large number of colors are available. Sometimes the colors can be mixed together by blending with the fingers or by superimposing them in successive layers to create optical mixtures, the blending that occurs only when the painting is viewed from a distance. For a clean and luminous result, it is best not to blend the colors very much with the fingers because pastels easily become muddied. They turn gray, more opaque, and increasingly white and less luminous as they are mixed. Mixing and blending pastels produces better results when not many colors are involved and when the layers are very thin. On the other hand, when the work is done using lines, the color underneath or the paper itself is visible through the lines, creating a fresh and natural color harmony, which would be lost if the lines covered the paper completely.

Claude Monet (1840–1926), Waterloo Bridge in London. Musée du Louvre (Paris). Pastels are a very suitable medium for quick color studies, which, like the one in this example, require a limited number of colors and are characterized by a quick and fluid style.

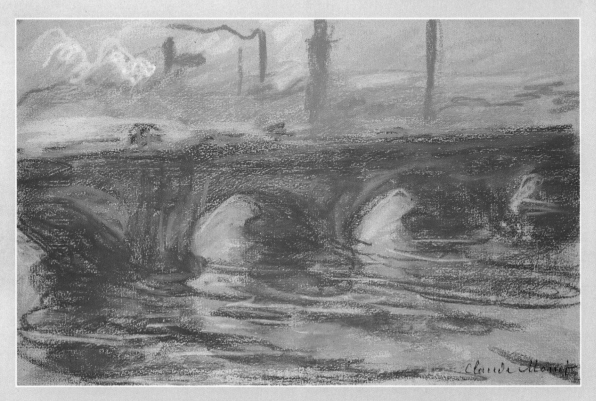

Color Quality

The beauty of pastels resides in the purity of the tones, in their immediate presence on paper, in the vitality of the lines or areas of color. Mixing them too much goes against the inherent properties of the medium. One of those properties is the ability to make the color "vibrate" in a way that is impossible to achieve with any other medium. That vibration is caused by juxtaposing various shades to create a single tone. Instead of mixing colors, artists can apply pastels in pure form on the paper using small lines and dots, resembling to some extent the Impressionist style, forcing the eye to "mix" the colors when viewed from a certain distance, without losing their individual character.

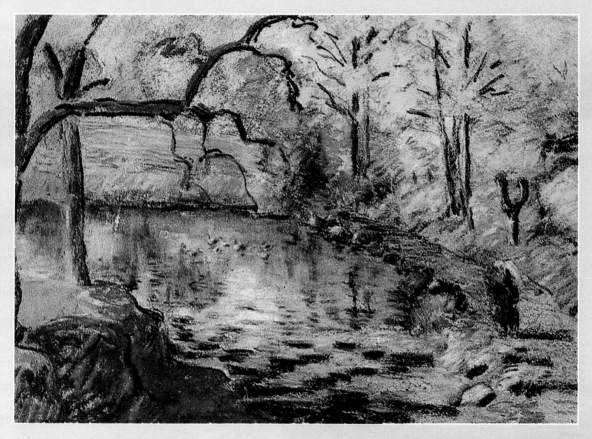

Camille Pissarro (1830–1903), Montfocault. Ashmolean Museum (Oxford, United Kingdom). This painting shows rich colors and outstanding looseness in its execution. Both characteristics are typical of pastels.

TYPES OF PAPER
As long as they have texture, watercolor papers are perfect for pastels, although their characteristic bright white surface does not aid in harmonizing colors. Handmade papers offer endless possibilities. Their handcrafted finish, with deckle edges and irregular textures, is one of their great attributes. Lightweight papers that have enough texture can produce excellent finishes, if the artist knows how to use the fine grain to his or her advantage. The most common paper for pastels is Canson, a moderately heavy paper with medium texture that is available in a wide range of colors.

A Port in Pastels

This exercise explains the principles of pastel painting applied to a water subject, and the basic techniques for blending and for mixing colors on paper. The theme is a northern port on a day that is especially gray. A gray paper has been chosen to be consistent with the color harmony.

The subject is characterized by its cold feeling: Grays, greens, whites, and light blues are the dominant colors, with a little warm touch provided by the brown stone of the jetty.

TECHNIQUES USED

♦ Reflections ♦
♦ Blending with pastels ♦

1 First, the composition is laid out by painting with the flat side of the bar of pastel. The image is sketched out with simple areas of color.

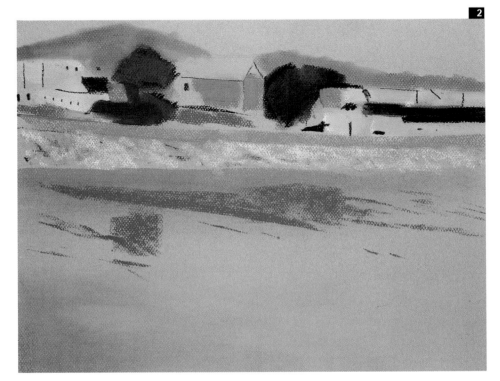

2 The colors are extended with the hand, mixing them if needed or blending them in the areas of the water where there is a gradual change of color.

THE COLOR OF THE BACKGROUND

It is always helpful to use color papers with pastels to guarantee good tonal harmony. The colors should be light so they do not condition the outcome of the work too much. For this exercise, ivory, pink, green, off-white, and neutral gray tones have been selected.

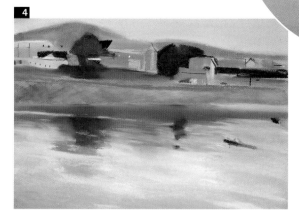

3 After harmony in the composition has been achieved and everything has been painted with the selected colors, it is time to touch up and retrace the outlines so they stand out against the color background.

4 Now the entire surface of the water in the foreground is lightened. The areas of color applied with pastels should follow the direction of the waves to make the form and color in the representation coherent.

5 This is the final result of the process. Because a small piece of paper was used, the painting has an Impressionist flavor, without too many details.

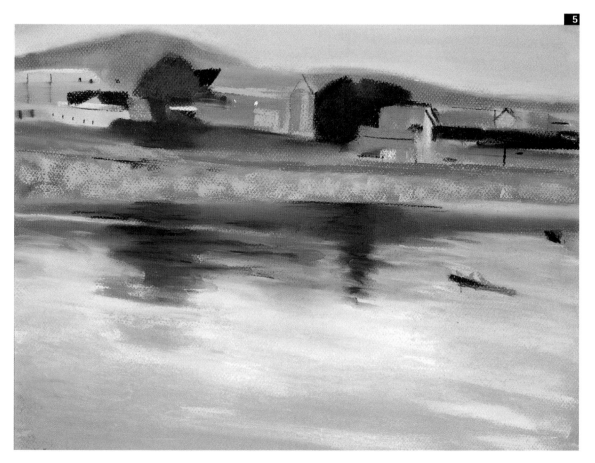

Watercolors

Water is the main element in watercolor painting. More than with any other procedure, watercolors completely depend on water as a diluent. Oils, acrylics, and pastels can be used directly in their pure form, but this is not possible with watercolors. Water determines the consistency of the colors, their tone and transparency, as well as how they mix with other colors. This dependency on water makes watercolor painting an art form with its own particular techniques, and to some extent, independent from drawing and painting. The proper use of water, the washes, and the way the colors are applied produce results of unmistakable vitality, which determine the very essence of watercolor painting.

This painting by Vicenç Ballestar is a good example of the artistic power and the intense dramatic effect that can be achieved when using watercolors in seascapes.

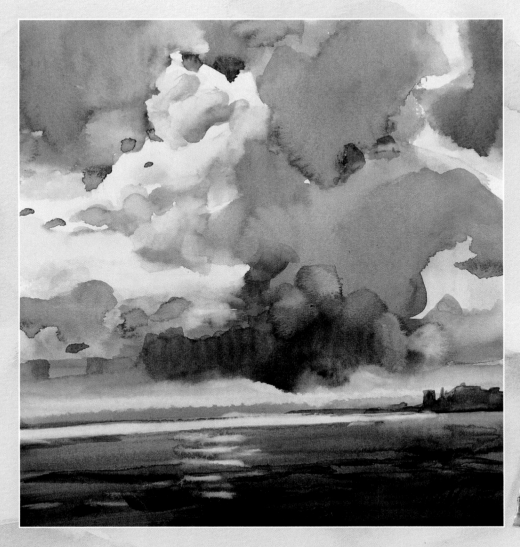

The Working Process

Unlike oil paint, watercolor is applied from light to dark, that is, placing light colors before dark ones. If the paint is applied while the paper is wet, the edges of the colored areas will be soft and the brush strokes will blend together, eliminating the harsh lines. There is no opaque white on the watercolor palette; instead parts of the paper are left unpainted or very lightly covered. Watercolors allow a variety of effects and color techniques, some of which are incorporating the texture of the paper to create ragged effects ("dry brush") and using other tools and resources such as sponges, masking liquid, sandpaper, or bleach to diversify the consistency of the painted surface.

TYPES OF WATERCOLORS
The professional watercolor artist paints equally well with the compressed, dry cakes of paint with water and with the moist type that is available in tubes. Every artist has his or her own preferences. The most common approach is to use creamy watercolor paints for large formats, reserving the dry type for smaller paints or for color studies and sketches.

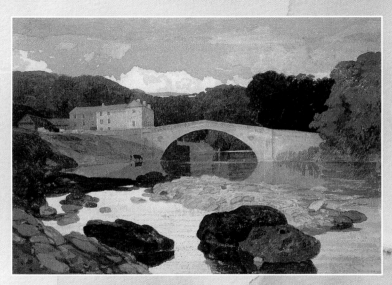

John Sell Cotman (1782–1842), The Greta Bridge. British Museum (London). In this classic work the watercolors have been applied methodically and meticulously to faithfully bring out the essence of the landscape.

Winslow Homer (1836–1910), The Lighthouse, Nassau. The Worcester Art Museum Collection (Worcester, Massachusetts). Modern watercolor paintings pursue highly colorful effects, executed with a technique that appears simple. But it only seems that way: the waves represented here are an exercise of technical virtuosity, executed with superb agility and ease.

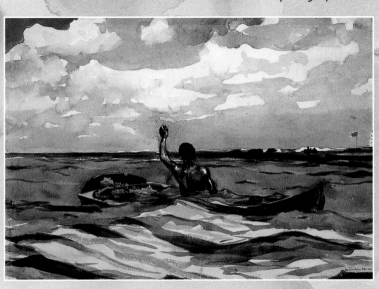

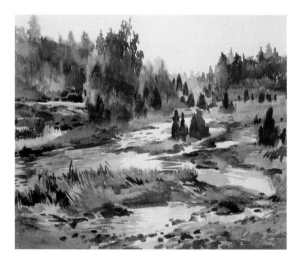

In this wash by Vicenç Ballestar, one can appreciate the level of elaboration to which a monochromatic wash can be subject. The great variety of tones in this landscape makes it possible to see them as colors.

Washes

Making a wash consists of spreading the paint diluted with a generous amount of water to obtain a large area of color that is homogeneous and variable in intensity, depending on the amount of water that has been added to the solution. Washes are a natural resource for every watercolor artist. Watercolors are suitable for this type of treatment because of the characteristics of the colors as well as for the results that can be achieved with them.

The transparency of the color plays an important role in washes, because the changes in the tonal intensity of the painting depend on them. The transparency of the application tones down the color until it is almost undistinguishable from the white of the paper. This property also allows the layering washes of different intensities to create multiple transparent effects.

Claude Lorrain (1600–1682), The Tiber Seen from Mario Mountain. *Musée du Louvre (Paris). The monochromatic wash is a classic technical resource in watercolor landscape painting.*

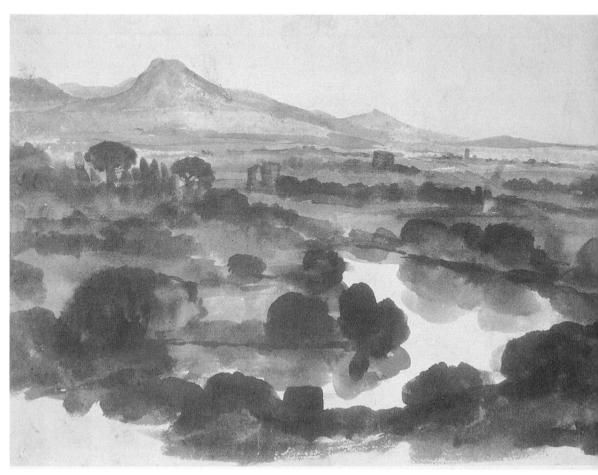

Monochromatic Washes

Traditionally, the concept of "washes" has been associated with paintings executed in one color with various degrees of intensity. A true watercolor master is adept at making monochromatic washes. First, the painter must study the landscape and identify the different values and intensities of light and shadow. Next, the artist has to translate those values and color intensities through paint and transparencies. Working in full color is nothing more than a step forward in this direction, and the watercolor artist who knows how to resolve a wash correctly will have no problem working in full color.

Monochromatic washes can be done in any color, but the most logical approach is to execute them with very dark colors because they allow for a greater number of gradations.

Flat Washes

A flat wash is a large area of color spread on the paper with a generous amount of water using a thick brush or a sponge. Flat washes are usually applied during the first stage of the landscape, for example, a color background that will make the subsequent watercolor tones stand out. These backgrounds are especially useful when painting the sky, for creating the overall tone and the luminosity of the landscape. The artist can intensify and adjust the effects of the light, the clouds, and so forth, on this type of background. Flat washes can also be applied to establish the overall tone of the entire painting, as in the case of foggy landscapes where tonal unity is required.

Once the flat wash has been applied, the artist can immediately proceed on the wet base if blending the color with the background is the desired effect, or over the dry surface if the artist wants the tones to stand out against the color of the background.

CONTROLLING THE WATER
With washes, it is more important to control the amount of water that is used in the solution than to mix the different colors precisely. Water can produce tonal variations that are rich enough for coloring the subject of the painting.

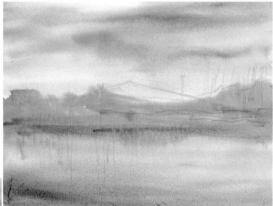

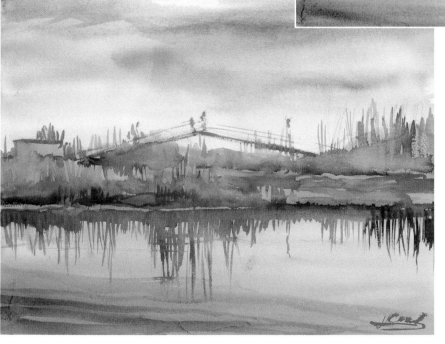

This is the result of a flat wash, that is, of spreading the paint over the wet paper, letting the colors mix more or less on their own.

The opposite effect from the previous wash is achieved when the surface is completely dry: The areas of color remain perfectly defined and outlined. Work by Miquel Ferrón.

Whites

The whites in a watercolor are, as we all know, the white of the paper. If the landscape requires such treatment, the artist must leave the paper blank in such a way that the unpainted areas become a natural part of the theme. To do that, the artist has to create reserves for the areas that are to be left unpainted. The reserves should be identified at the very beginning of the process because it is difficult to restore the purity of the paper once the painting is in its advanced stages. Often, the artist leaves large areas unpainted, which will later be reduced and defined as the work progresses. The most common approach is to shade the reserved areas with light color washes so they do not appear harsh, like holes or tears, against the color scheme of the work.

Color Reserves

Reserves can also be made over the background color, for example over a flat wash. When the reserves are the white of the paper, they should be planned carefully to avoid corrections. Given the nature of watercolors, where the paint is applied from light to dark, the reserve should be lighter than the next color to produce a luminous effect. All these types of reserves should be executed on dry: It is impossible to make a well-defined reserve on wet because the outlines and the shape of the reserve will be blurry.

TONAL BALANCE
The white of the paper creates a luminosity that must be in balance with the rest of the colors of the painting. If the painting calls for large reserves, strong contrasts are required to counter the brightness of the white areas.

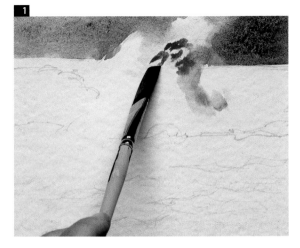

1 The sea foam in a watercolor painting must necessarily be the white of the paper. Artists paint the surrounding foam so the contrast makes the image stand out.

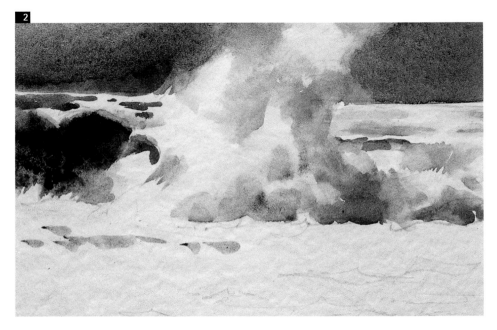

2 Thanks to the blue shading applied around the white reserves, the white foam of the waves that break at the edge of the beach becomes very visible.

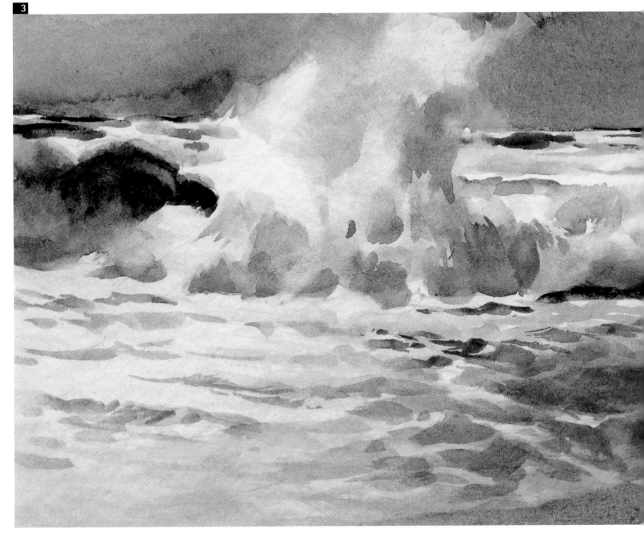

3 When the white reserves have been established, the rest of the painting is completed.

Reserves and Drawing

Making reserves, with either the white paper or the background color, is a way of defining the contours of forms, that is, of drawing them. The shapes are outlined by the colors that surround them in the painting. A big part of watercolor painting is working with different color reserves. Therefore, reserves are a technique not only for applying color but also for drawing and for creating forms. Any shape can be represented with watercolors by using reserves or by just painting only its contour. Contrast can also be created by using reserves; for example, by darkening the banks of a river, the clarity and luminosity of the water is emphasized.

This is a painting created with the "dry brush" technique—in other words, by using a single color and very little water. Here we can also see how the white of the paper that indicates the stream of water has been reserved.

A Wash

A wash is the basic watercolor technique. It consists of manipulating the color with water. The intensity of the color, the value of the paint, the tonal range and variations, are all directly related to the water. In this exercise (which is an abbreviated version of a different one that appears at the end of the book), we show the process of making a wash with two mixed colors turned into one.

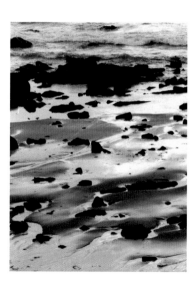

This same subject will be painted in more detail in later pages. It is important to learn how it can be approached in a simplified manner without ignoring the proper represen- tation of the water receding from the beach during low tide.

MATERIALS
- Flat, medium synthetic brush
- Medium-grain watercolor paper
- Hooker's green and burnt sienna watercolors

1 A very diluted layer of the mixture of green and burnt sienna is applied. The areas left blank on the paper will represent the highlights on the water.

TECHNIQUES USED

◆ Wash ◆
◆ White reserves ◆

2 A very saturated application of the mixture looks black, which turns the rocks of the beach into simple silhouettes.

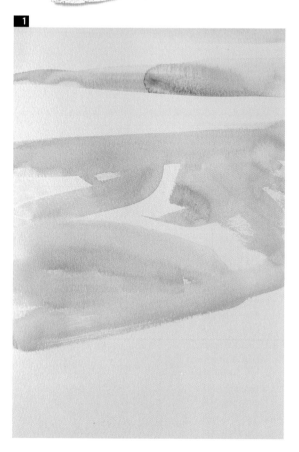

3 The first areas of color are defined with tones that are a little bit darker. The work is executed loosely, letting the brush move freely.

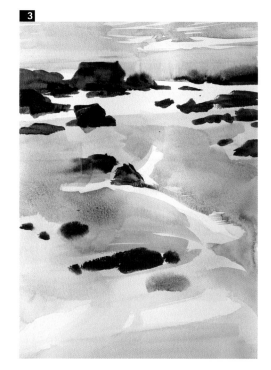

4 A few black silhouettes conclude this simple wash.

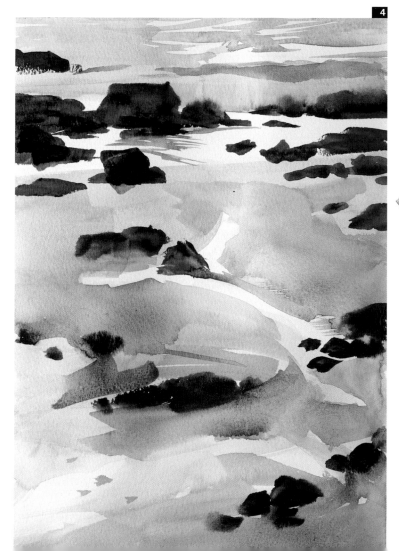

THE PALETTE OF THE WATERCOLOR ARTIST

The most common colors used by watercolorists are yellow, cadmium red, carmine, yellow ochre, raw umber, burnt sienna, English red, Hooker's green, and ultramarine blue. Many artists add other colors such as cerulean blue, emerald green, permanent green, and cobalt violet or Payne's gray to this basic palette. Watercolor artists use either high-quality paints in tubes or dry cakes (or "pans"). The illustration in this section shows a special palette for watercolor artists, with big partitions for the paints and large spaces for mixing.

This is a metal palette that can hold as many as 16 colors. Each color is placed in its own space. The artist need not be concerned about using the paint immediately, because even if it dries it can be reused by simply wetting it with the brush.

Oil Paint

This is the one medium that suits all artists in general, and landscape painters in particular. It is a medium that adapts to the needs and styles of every artist as no other does. The working process is a bit more complex than other procedures, but the only considerable difference is that oils take longer to dry. This forces the artist to work in sessions, that is, more or less long periods of time. When work is resumed, the colors that were used during the previous session will still be fresh.

Édouard Manet (1832–1883), Battle between the Kearsage and the Alabama. *John G. Johnson Collection (Philadelphia). Oils are the preferred medium for large paintings, for compositions that require a lot of work and a fine finish.*

William Turner (1775–1851), The Slave Ship. *Museum of Fine Arts (Boston). Oil paints alone (and a master hand) are capable of heightening the overall effects of color to fantastic and lyrical extremes.*

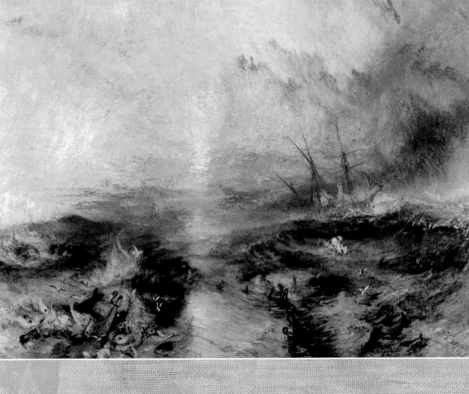

Colors and Mixtures

Oil paints can be mixed very easily. To minimize or to prevent colors from becoming dark and muddied, it is best to reduce the number of mixtures. The more elaborate the mixture the greater the possibility that the chemical components of the paint will react with one another. The ideal approach would be to apply the paint in pure form, lightened or darkened with another color. But this ideal is attainable only by experienced painters whose palettes have been refined through years of practice. They know what colors are essential for their work and how to alter the way they are perceived by playing colors against each other, without actually mixing them.

Simon Denis (1755–1812?), River. Private collection. *Oil paints are the most suitable medium for a realistic representation of water.*

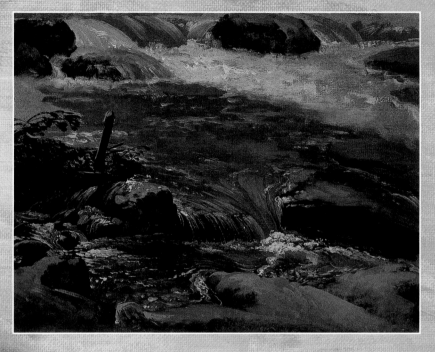

BRUSHES FOR PAINTING WITH OILS

The brushes most commonly used for painting with oils are bristle brushes. Some artists also use badger or sable brushes for some work and for delicate details. Bristle brushes offer the best characteristics for oil painting, they hold a lot of paint, they endure the kind of wear and tear required by impasto, and the hair improves with time. In fact, with use, the fibers of the tip expand, increasing its capability of holding more paint. Badger and sable brushes are suitable for smooth work that does not involve impasto, and especially for painting lines and fine details.

The Function of the Brush Stroke

The sequences of this brief exercise will demonstrate the function of the brush stroke in resolving water subjects with oil paints. The theme in question is a waterfall with rocks. The small cascades that form are easily painted with vertical brush strokes.

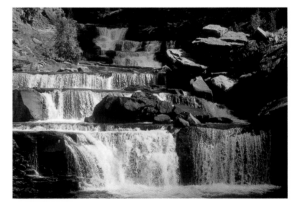

MATERIALS
- Assortment of oil paints
- Stretched canvas
- Medium round bristle brush

At first, the subject may look difficult because it involves moving water. It consists of a current that generates very complex turbulent and foamy water. But an Impressionistic approach to the subject, which is captured with a series of light and dark areas of color, proves that it can be resolved without difficulty.

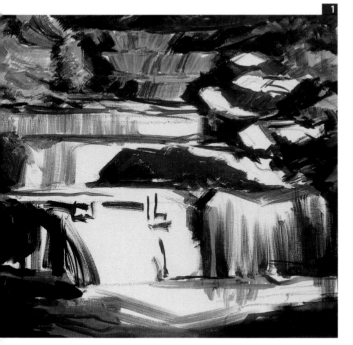

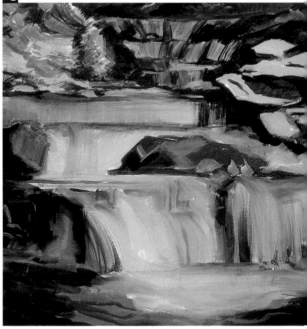

1 The subject must be approached as light and dark areas of color, the lighter ones being those that represent the waterfalls. At first, these areas are left white, as if it were a watercolor painting.

2 The direction of the white brush strokes, which are for the most part vertical, define as much the direction as the power and speed of the water falling over the rocks.

TECHNIQUES USED

◆ Highlights ◆
◆ Direction of the brush stroke ◆

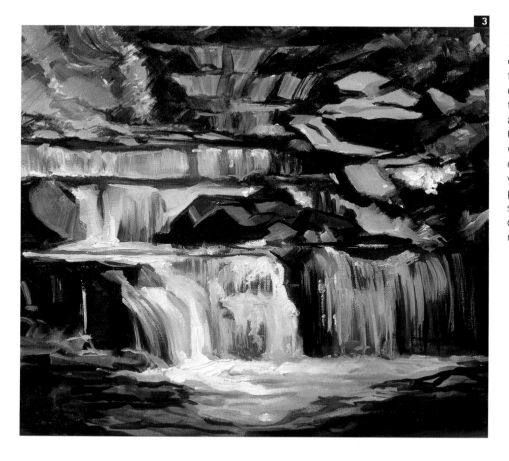

3

3 The representation of this waterfall is finished by adding dark brush strokes to the previously applied light color. Oil paints can be worked light over dark and vice versa, and this property makes subjects like this one easier to resolve.

TINTING WHITES

Oil colors can be tinted to levels that are unattainable with any other media. The white areas of this painting have been tinted with light green, which is what gives the foam the feeling of transparency.

TRANSPARENCIES

Oils are the most appropriate media for painting the transparency of the water. Because oil paints are easy to mix, the different tones blend with each other in a way that is almost unnoticeable. This allows experienced artists to achieve very delicate and realistic results, like the one in the illustration below.

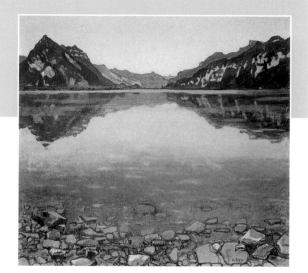

Ferdinand Hodler (1853–1918),
Landscape at Lake Thun. *Private collection.*

Oil Impasto

This exercise demonstrates the application of impasto in a spectacular subject: a wave breaking against the rocks. Impasto is involved especially in the white color of the spray, which, as we know, is represented with white reserves when painting with watercolors. With oil paint the process is reversed: Whites are created by accumulation of color.

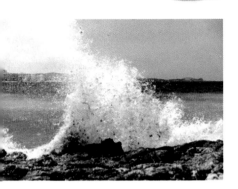

A wave breaking against the rocks is a very interesting subject for working with large amounts of paint. In addition to creating the expansive effect of the water, impasto enriches the painting with a great variety of textures.

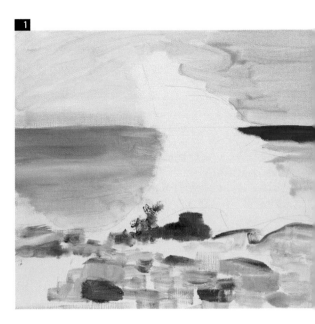

1 The composition is sketched in very simply—quick blue brush strokes for the sky and the sea and burnt ochre tones for the rocks. The canvas is left blank for the foamy waves.

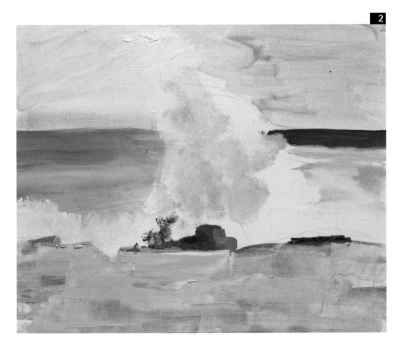

2 The colors of the rocks are applied over the entire lower part of the composition with a spatula. By doing this, new shades are formed from the spontaneous mixing of the colors with the previously applied brush strokes. The area reserved for the foam is shaded with gray and blue tones.

TECHNIQUES USED

♦ Highlights ♦
♦ Impasto ♦

3 The white color is built up with repeated brush strokes heavily charged with paint. They add thickness to the pigment on the canvas.

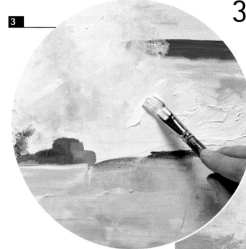

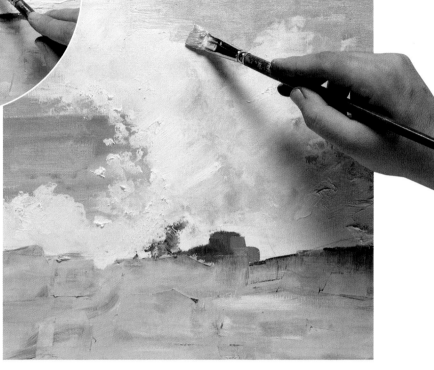

4 Blue brush strokes are added to the upper part of the waves to represent the sky seen through the transparent spray of the foamy wave. The blue and white colors of the wave are blended together directly on the canvas.

5 The final result contains all the expansive power of this theme while displaying a typical quality of oil paintings, which is an abundance of color and generous impasto.

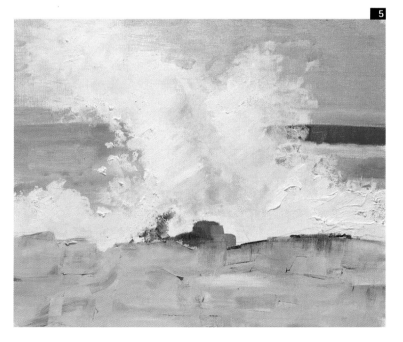

IMPASTO

Heavy applications of paint should be used in the light areas of a painting, which is where impasto can offer a more energetic appearance and an effective contrast of textures. In paintings like the one illustrated here, the impasto has been reserved for the foamy waves, emphasizing the dynamic effect of the water.

Acrylic Paint

Acrylic paints are the most recent introduction to the market and have gained many followers among artists. Acrylics are worked pretty much like oil paints, the only difference being that acrylic paints dry much faster. This speed makes working with them very easy, because even impasto and areas where there is heavy accumulation of paint will dry in a matter of minutes. But acrylics are suitable not only for paintings where heavy pigmentation is required but also for work where the paint needs to look thin. In fact, acrylic paints can be handled with the same subtlety as watercolors, creating areas of thin and delicate paint. They will never have the same transparency as watercolors, but the properties of acrylic paints make them the ideal medium for beginner landscape painters, and especially for those who include water subjects in any of their representations.

TRANSPARENCY AND OPACITY
Contrasting transparent and opaque areas (very diluted and dense colors) is one of the best tricks that an artist can use when working with acrylic paints, especially when dealing with subjects where water is the main protagonist.

David Hockney (b. 1937), Swimming Pool and Steps. Private collection. In this acrylic painting, the water has been represented very delicately. Thin layers of very diluted paint have been applied to create an array of colors that convincingly mimic the waves in the water.

Painting Water in Landscapes

The following pages include the detailed step-by-step development of seven paintings created using different techniques to resolve the water subjects represented in them.

This section includes a total of seven exercises using all the techniques studied so far. Each theme presents different problems, which are approached by putting into practice the previously covered techniques. These paintings can be executed with any of the techniques studied, but we thought it was more appropriate to pair them with those procedures that better respond to typical effects such as highlights, reflections, undulation, color, and so forth. Each one of the exercises is explained step by step with the reasoning used by the artist. Notice how it is always necessary to adapt the medium to the chosen theme and how the results always follow the natural tendency of the medium used.

Any medium is suitable for any subject, as long as it is adapted to the qualities of that medium without forcing them.

As explained in previous pages, understanding the medium alone ensures the correct approach to the work. The biggest mistake that one could make would be to try to achieve certain results typical of one medium when using a different one. The following pages demonstrate that any medium is suitable for any subject, as long as the work is adapted to the qualities of that medium, without forcing them and without expecting more than they are capable of.

The procedures illustrated in this section cover a great variety of the characteristics typical of landscapes in which water is the basic element.

Low Tide with Watercolors

This is a very unusual seascape theme: puddles left behind on the beach by receding water at low tide. It is a very interesting subject for many reasons. As far as color is concerned, the subject of the composition resembles a grisaille of greens, with the beautiful contrast of the black outline of the rocks and the pure white of the sky's reflection on the wet sand. To complete the scene, the waves in the water tie together all the elements of the composition.

The interest of this subject resides in its forms and colors: The black silhouettes of the rocks are an interesting counterpart to the fluid grays and greens of this composition.

TECHNIQUES USED

- ◆ White reserves ◆
- ◆ Washes ◆
- ◆ Reflections ◆

1 The preliminary drawing is quite elaborate because it must include the winding forms of the rocks and puddles of water that extend over the sand.

2 The first step is to create the background color for the painting by applying a very thin wash of gray green, mimicking the ripples formed by the sand as a result of water flowing in and out of the puddles.

MATERIALS

- An assortment of watercolors
- Medium-grain watercolor paper
- One flat, medium bristle brush and one thin, round sable brush
- Hard graphite pencil

3 The waves at the upper part of the composition are painted with the same color used for the background, reserving the whites for the areas that receive the most light. The rocks are painted with blue mixed with carmine and green.

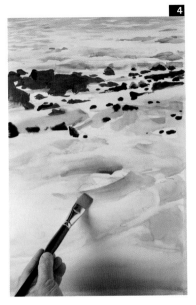

4 This black is applied without much dilution. Some of the tones are intensified on the wash, increasing the proportion of green (mixed with a little carmine to make a gray color), to represent the ripples in the wet sand.

5 As the modeling of the terrain continues, dark touches of color representing the rocks and pebbles are added. None of them should be painted in detail, but it is important that they maintain a proper silhouette.

6 A few strokes of blue-gray, which fits perfectly with the overall palette, are added to enliven the array of greens that cover most of the composition.

7 The flowing effect of the small pools of water is represented with a technique that is characteristic of watercolors. The puddles of color create a diffused effect that changes rapidly from light to dark.

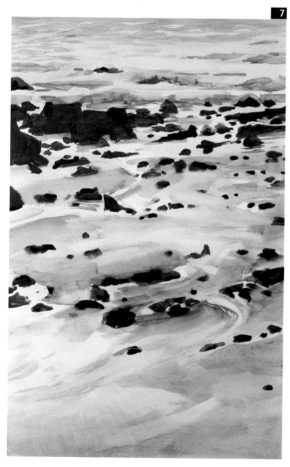

BLACK WITH WATERCOLORS

Watercolor artists use neither black nor white. The white is always represented with the white of the paper, and black is never a true black but rather a very dark gray with an undertone of some color, which can be cool or warm. It cannot be any other way when the black is the result of a mixture. Ideally, black is obtained from mixing the three primary colors (red, yellow, and blue), which is how artists create it, although normally their darker counterparts are used (ultramarine blue, carmine, and emerald green).

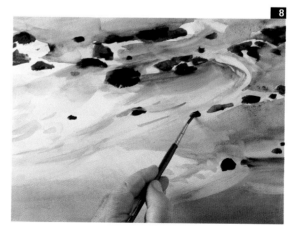

8 Although the colors used are very few, their harmony has been enhanced with the addition of blues, grays, and brighter greens. All these colors contribute to the creation of the impression of the wet and fluid subject.

THE SHORE

The transition between sea and land makes the shore one of the most important features of the representation. The artist must negotiate the white colors created by the water extending over the sand as a fine layer, avoiding sharp tonal contrasts.

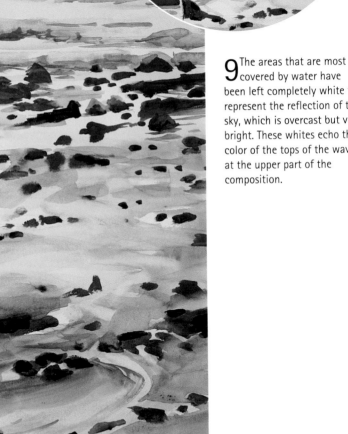

9 The areas that are most covered by water have been left completely white to represent the reflection of the sky, which is overcast but very bright. These whites echo the color of the tops of the waves at the upper part of the composition.

10 Finally, one can see how the color limitations of this painting have not prevented its creator, Vicenç Ballestar, from creating an array of tonalities dominated by the unmistakable effect of flowing water, cold and murky, around the ripples formed by the sand.

A Lake Shore with Acrylics

A clear landscape reflected on the pristine waters of a lake is the subject examined in this exercise executed with acrylic paints. This medium offers the artist an extensive palette of cool and warm tones with which to represent this attractive landscape where the spring colors are in perfect harmony with the vivid tones of the terrain and the cool colors of the sky.

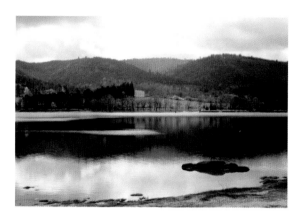

This spectacular lake scene is an inviting subject for a detailed painting with rich colors. The clear atmosphere, crisp and cool, is enhanced by the reflections of the clouds on the still waters of the lake.

MATERIALS
- An assortment of acrylic paints
- One thin, round brush and one flat, wide brush, both synthetic
- Stretched canvas
- Hard graphite pencil

TECHNIQUES USED
◆ Highlights and reflections ◆

1 First, a pencil sketch is made of the composition. Next, the drawing is retraced with carmine color to make the lines more visible.

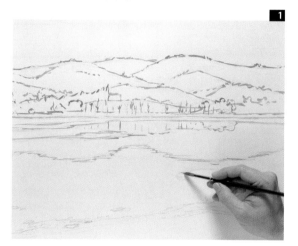

2 The first colors are applied very diluted with water, enabling the brush to flow freely over the canvas to make a quick preliminary color layout of the composition.

3 Next, the yellow colors that are in the central area of the composition are added to the cool tones. These yellows have a slight green undertone, which ties them to the vegetation that covers the mountain.

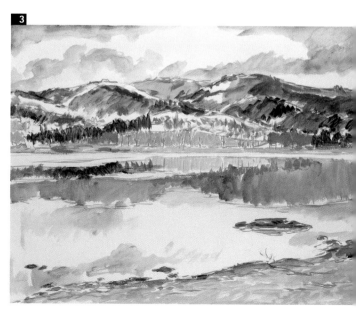

DRYING TIME

Acrylic paint dries very quickly. If the color is very diluted, it can dry as fast as watercolors. When applied heavily, it takes longer to dry, but under normal conditions that time is usually reduced to a few minutes.

This considerably limits the ability to blend colors, but it favors the speed of the process. Some artists choose to add a drying retardant to the water or to mix it directly into the paint.

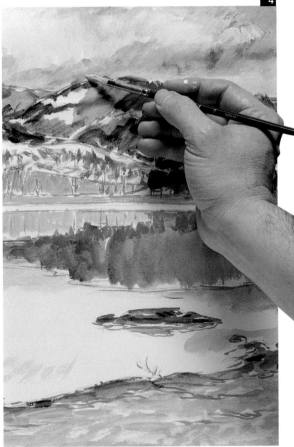

4 Notice how the reflections of the green mountains have been painted with a violet color to intensify the coolness of the tones. The reflection is always darker, and in this case also cooler.

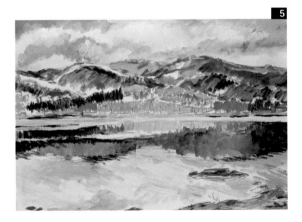

5 The sky has been shaded with pink colors to create the iridescent effect of this cold Nordic morning.

6 The vibrant green colors of the mountains have been gradually shaded until they become grayer, which better suits the color of the sky and by extension, the overall feeling of the landscape.

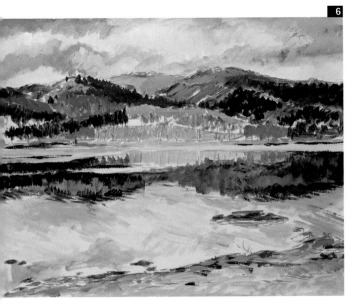

WATER AND OTHER DILUENTS

Most artists use water to dilute acrylic paint, but it is also possible to use an acrylic medium, which is a milky liquid used to bind the colors. This medium provides more consistency to the colors, and a brighter finish.

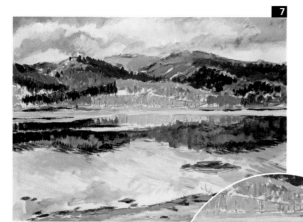

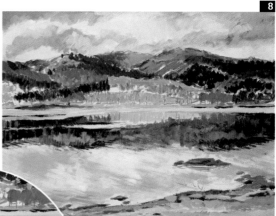

7 In this step the soft ripples of the water have been painted using repeated soft brush strokes alternating light and dark colors, which create more contrast in the transitional areas between the reflection of the mountain and of the lake.

8 Here, white brush strokes have been added to the reflections that are put in motion and broken up by the waves as if they were fine water filaments. This is the area where the brightest part of the sky is reflected, which is represented by the lighter white color.

9 The soft motion of the ripples of water has been represented through the methodical application of contrasting colors representing the reflections of the mountains and the sky.

10 The final stages of the work basically consist of toning down the color contrasts, shading the green of the mountains and the areas of the foreground.

11 The bands of white color are now visible far on the distant shore. These bands represent the bright, shallow parts of the water on which the line of trees cannot cast any reflections.

To finish the work, a few details of the reflections are touched up to suggest the undulation of the lake in the most distant areas. This must be done carefully so the magnificent results obtained thus far will not be ruined.

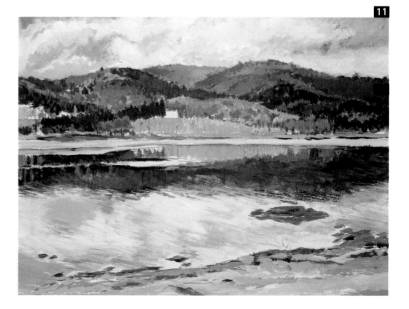

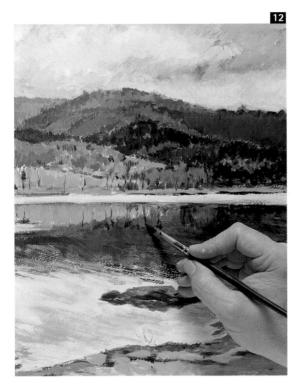

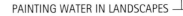

THE SIZE OF THE BRUSH STROKE
In this painting, the size of the stroke, small but clearly visible, contributes to the vibrancy of the color, which enlivens the composition. The brush strokes always have the advantage of enhancing the color planes and of reinforcing the contrasts.

12 There are only a few details left to apply over the green color of the mountains, after which the painting will be considered complete. The level of finish is just appropriate for ensuring that the freshness of the composition is not compromised.

13 When the finished work has a high degree of detail, there is a richness present in each one of the colors involved (greens, yellows, blues, grays, etc.). Josep Torres has achieved excellent results, which do justice to the beautiful subject selected.

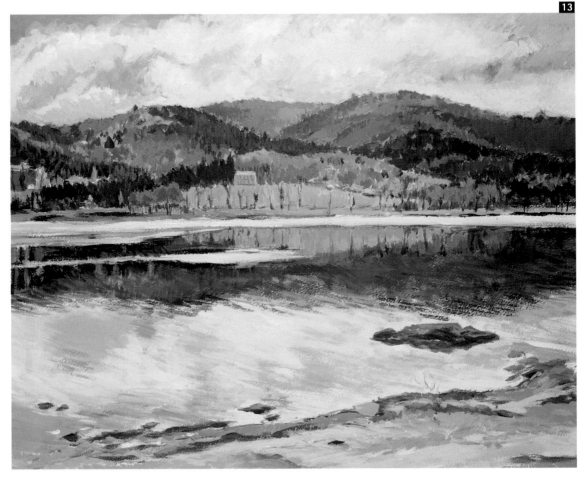

The Sea from a Cliff, with Oils

With the exception of a few, very few, Romantic examples produced some forty years earlier, one could say that the Impressionist painter Claude Monet was the precursor of the cliff theme as a pictorial subject with his famous series of seascapes painted in Normandy (France) at different hours of the day. The subject of this exercise, executed by Carlant, is reminiscent of the compositions of that great master and has a particularly interesting aspect, which is the view of the sea from an elevated vantage point.

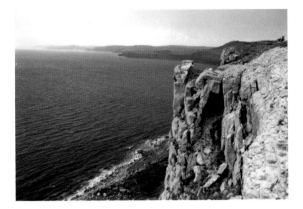

The subject is a view of the sea from the top of a cliff. The rocks stand out in the close foreground against the great plane of the dark sea, which extends beyond them in the background.

TECHNIQUES USED

◆ Representing waves ◆
◆ Blending with oils ◆

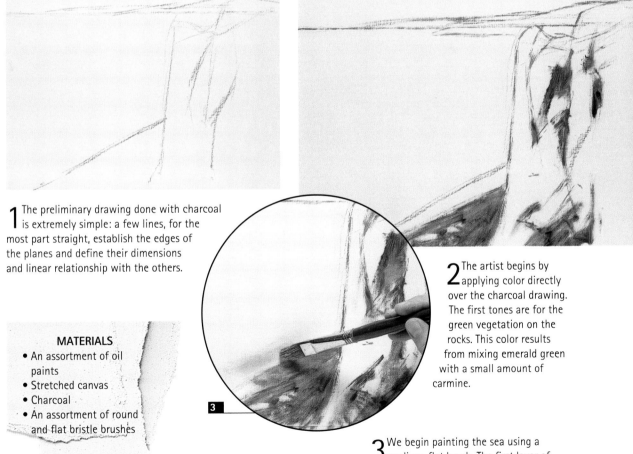

1 The preliminary drawing done with charcoal is extremely simple: a few lines, for the most part straight, establish the edges of the planes and define their dimensions and linear relationship with the others.

MATERIALS

- An assortment of oil paints
- Stretched canvas
- Charcoal
- An assortment of round and flat bristle brushes

2 The artist begins by applying color directly over the charcoal drawing. The first tones are for the green vegetation on the rocks. This color results from mixing emerald green with a small amount of carmine.

3 We begin painting the sea using a medium, flat brush. The first layer of paint should be light and not too saturated with color.

THE COLOR OF THE SEA FROM ABOVE
According to the logic of reflections, the surface of the water should be darker the higher our vantage point is. As we know, this is caused by the fact that the amount of light that illuminates the sea from above is less than that which is reflected by its surface when the point of view is level with the waves. From a high vantage point, a good portion of the sunlight is absorbed by the mass of water, and the sunrays reflected by the mirrorlike surface are too oblique, and therefore can be perceived only from shore.

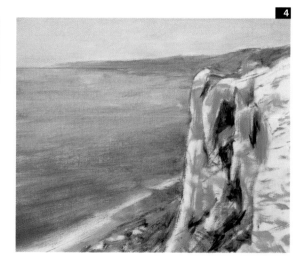

4 The surface of the sea has been completely covered with horizontal brush strokes of ultramarine blue, to which a mixture of white has been added in the areas closest to the horizon.

5 A large portion of the rocky area in the foreground has been left unpainted, so color can be built up with individual brush strokes. These areas will combine cool and warm tones, in response to the nature of the minerals in the cliffs.

6 The volumes of the rocky surfaces are created through the accumulation of thin brush strokes of light-color paint, which is produced by mixing ochre with white and a small—very small—amount of ultramarine blue.

7 The artist begins to darken the surface of the sea by applying long brush strokes diagonal to the line of the beach. This darkening effect should be applied to the entire sea plane.

8 The entire surface of the sea is darkened with blue mixed with a small amount of white, which should be more intense in the areas closest to the horizon. Also, the features of the distant land are painted with cool colors, all of which have a blue undertone, together with some touches of burnt sienna for definition.

9 The sea in the foreground is the darkest area of the mass of water, and is painted with Prussian blue and black. To counterbalance the tonal changes of the sea, the rocks are also shaded with details of a darker color.

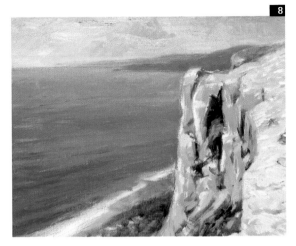

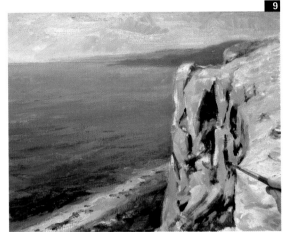

10 The area of the foreground has a dense linear texture resulting from the multiple contrasts between the rocks and the vegetation. Here, the grays and greens are alternated with a variety of darker tones that define the volume of the shadows.

11 The sense of space has been successfully achieved. The rocky foreground clearly stands out above the shore against the great mass of the sea.

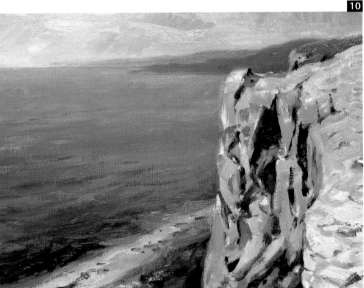

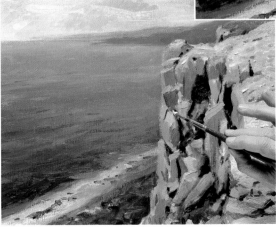

WARM AND COOL COLORS
The most common approach in art is to reserve the warm colors for the foreground of the composition, but in this theme, the closest plane is cold, and so is the distant area of the sea. However, the basic contrast that creates a perception of distance is achieved in this painting by the difference in the amount of detail, which is greater in the foreground than in the middle ground and the background.

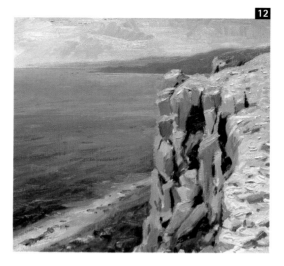

THE WAVES FROM A DISTANCE

From a high vantage point, the waves resemble an intricate pattern of blues and grays of various intensities that interact rapidly and produce an effect of constant change. The foam and reflections do not play a part. Therefore everything is reduced to a series of brush strokes of different tones of blue (lighter and darker) that are built up on the canvas to give unity to the surface of a sea with small waves caused by the wind.

12 These are the last details that help define and make the protruding rocks more realistic. The most illuminated areas of the rocks are painted with thick paint using a very fine, round bristle brush to make the rocks stand out and appear almost three-dimensional against the rest of the composition.

13 The sea is a large plane of colors ranging from the deep blue of the foreground to the light blue of the horizon. The soft gradation between the two colors creates the effect of monumental distance and space, which adds great interest to this work by Carlant.

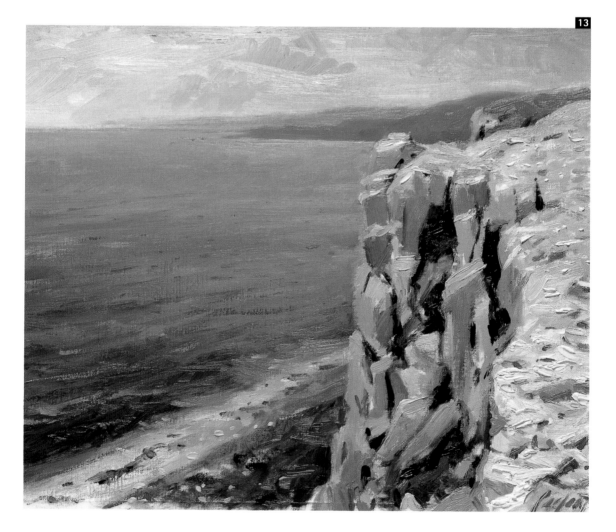

Reflections with Color Pencils

Color pencils are more effective in the resolution of details and for minute shading than for large-scale applications. This is why the theme of this exercise (a typical view of a lagoon) is ideal for the particular type of treatment afforded by color pencils: precision in the detail, richness of color, and a continuous density in the texture created by pencil lines on paper.

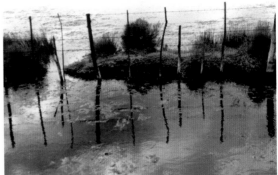

The visual interest of this subject resides in the play between the plane and the surface, defined by the algae and by the dark reflections of the sky and the posts. The chromatic resolution, which is dominated by gray blues and greens, also responds to the logic of the surface and the reflections.

1 The outlines of this theme have been sketched out in as much detail as possible with a hard lead pencil (which makes a light line), in order to define the boundaries of the areas that need to be colored with the pencils.

MATERIALS
- An assortment of watercolor pencils
- Thin, round watercolor brush
- Medium-grain watercolor paper

2 The base color for the vegetation has been laid out with an overall layer of yellow color, reinforced with ochre tones for the edges of the grassy areas.

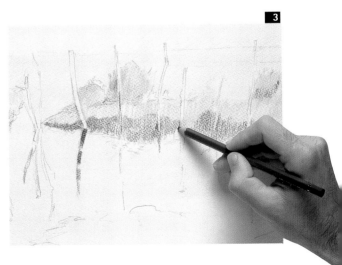

3 The area where land makes contact with the water has been darkened to represent the small mounds reflected on the surface of the lagoon. Burnt sienna is the color used for this step.

TECHNIQUES USED
◆ Coloring the reflections ◆

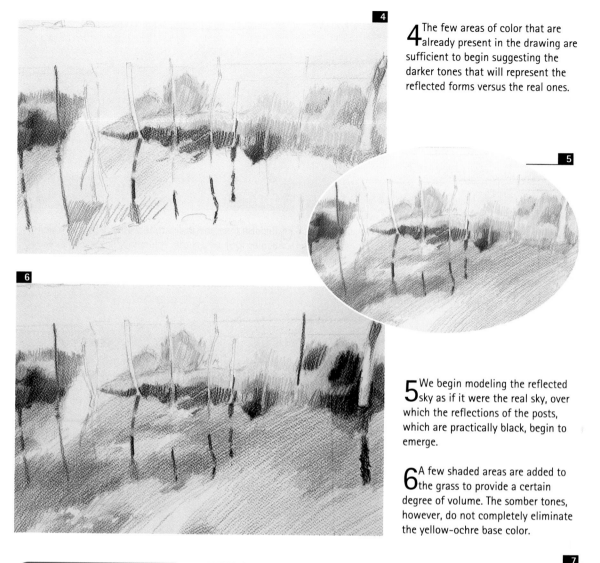

4 The few areas of color that are already present in the drawing are sufficient to begin suggesting the darker tones that will represent the reflected forms versus the real ones.

5 We begin modeling the reflected sky as if it were the real sky, over which the reflections of the posts, which are practically black, begin to emerge.

6 A few shaded areas are added to the grass to provide a certain degree of volume. The somber tones, however, do not completely eliminate the yellow-ochre base color.

THE GRAIN OF THE PAPER

The normal tendency for painting with color pencils is to use a paper whose surface is smooth. That way the lines will be clearly visible at the conclusion of the work. In this case, we have used a watercolor paper whose texture enhances the pencil lines. But this same texture will be less visible when, at the end of the process, a wet brush is applied to certain areas of the painting.

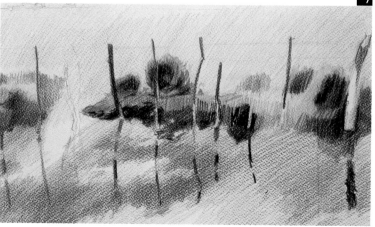

7 Continuing with the modeling of the vegetation, green tones are added to complete the coloring of the grass, which looks slightly dry. The outlines of the reflections have been defined while maintaining the initial dark coloration.

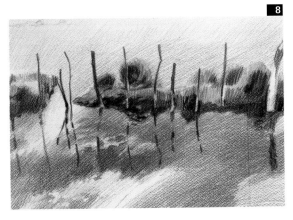

8 Moving on to the reflections of the clouds, new green tones are added to "muddy" the initial blue colors, and with this, the water of the lagoon begins to acquire a denser appearance. Some of the colors are used to indicate reflections, and others transparency.

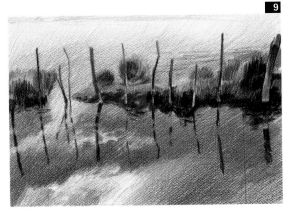

9 Reddish tones are added to the reflected mass, which begins to show the true coloration that combines the dark reflection of the sky and the color of the muddy bottom.

10 The reflections of the shadows are created by accumulating different pencil lines of blue, green, and red. These "black" touches are very rich in color and texture because the successive pencil lines create a dense pattern in those areas.

11 A brush charged with clean water is used on the light lines of the background to blend their texture and to lighten them even more.

12 The area of the foreground of the composition containing the reflection of the light sky has also been brushed with water. The contrast between the color and the line in this part of the painting reinforces the effect of the proximity of the surface with respect to the transparent appearance of the background.

WATERCOLOR PENCILS
Watercolor pencils are used exactly the same way as conventional pencils. The only difference between the two is that with the former, the artist may decide at the last minute to use a watercolor brush moistened with water to blend or to spread the colors of certain areas of the painting.

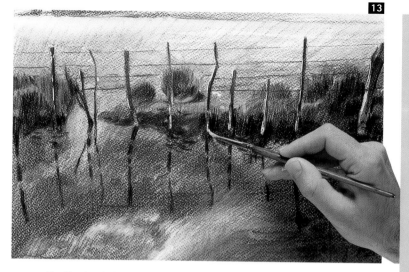

13

13 Finally, the darker colors of the posts and their reflections on the water are painted. These tones, which were dark from the beginning, will be even darker now with the effect of the water.

14 This is the result of the work done by Óscar Sanchís. He has achieved a very rich and completely convincing coloration that mimics the murky water under the dark, gray sky.

WHY USE A WATERCOLOR PROCESS

If color pencils are an artistic medium in their own right, why use them as watercolors? The answer is simple: to blend the pencil lines and to consolidate the areas of color. This way, the artist can create contrasts within the general texture of the painting by alternating areas of lines with the characteristic look of watercolors. For this reason, it is important to use the watercolor process only at the end, when the line work that creates the texture has been completed.

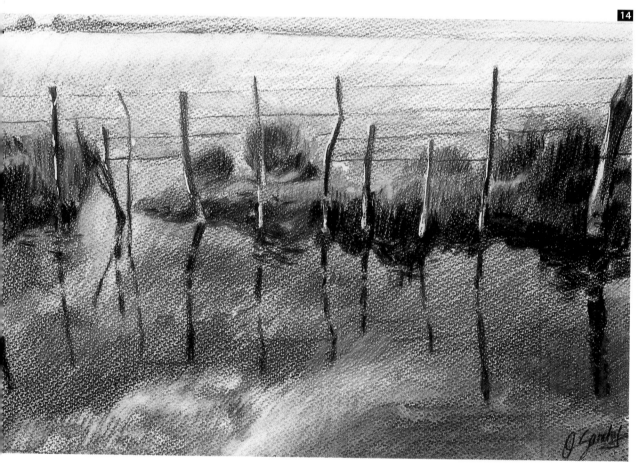

14

Transparencies in Clear Water, with Gouache

A serene sea and an abrupt shoreline on a sunny day are the best possible conditions for practicing painting transparencies. Marine transparencies tend to be clearer than those of rivers, and we find in them richer green and emerald tones. If those transparencies include a rocky bottom, the richness is enhanced even more because the rocks create an interesting pattern of lights and shadows.

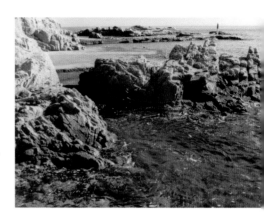

The theme chosen for this exercise is a seascape characterized by the brightness of the water and the sharp, clean transparencies.

1 The preliminary drawing is laid out as if it were a complete work in itself. It not only serves as the sketch for the general composition but also contains the detailed contours, values, light, and shadows for the resolution of all the features of the painting.

2 This illustration shows the degree of elaboration of this drawing. It includes enough detail to guide the work in color.

TECHNIQUES USED

- ◆ Representing the waves ◆
- ◆ Representing the reflections ◆
- ◆ Representing transparencies ◆

MATERIALS

- An assortment of gouache colors
- Thick and thin ox-hair brushes
- Fine-grain watercolor paper
- Hard graphite pencil

3 The painting process begins by applying color for the background of the sea, using ultramarine blue slightly lightened with white.

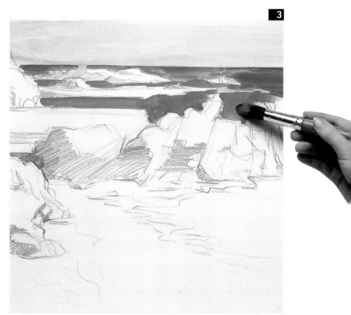

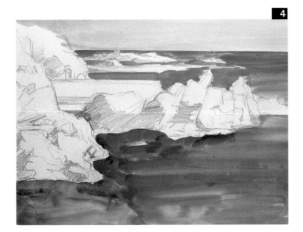

4 The middle ground of the sea is covered with ultramarine blue, which should be a little bit darker than the previous one, and the foreground is saturated with green dissolved with a large amount of water.

5 All the warm tones of the rocks have ochre and burnt sienna as a base, which has been made slightly gray by adding a small amount of ultramarine blue. The paint has been diluted with a large amount of water to facilitate spreading it on the paper and to give us an idea of the initial effect of the overall tone.

BLUES AND GREENS
The blues in this painting are all mixtures of ultramarine blue. This color was applied straight from the tube or combined with small amounts of cobalt violet or black. The greens are emerald green lightened with a little bit of white, or given a bluish cast by mixing it with a small amount of ultramarine blue. Both colors work very well together, and combining them rarely produces clashing or muddy results.

6 The color of the darker shadows is obtained by mixing violet and burnt sienna. The resulting combination is a dark purple that goes very well with the tan color of the rocks.

7 Notice the overall effect of the seascape. The color contrasts are especially strong in the foreground and the middle ground, whereas in the background the colors are less contrasting.

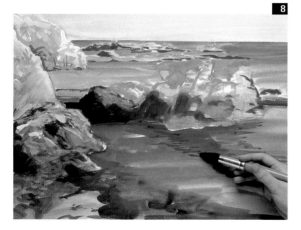

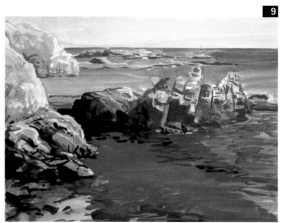

8 Thin brush strokes of more saturated blue are added over the blue area of the foreground. These brush strokes create the dark reflections of the rocks that are broken into small segments by the motion of the waves.

9 The intense contrasts that have been created in the foreground have achieved a sense of transparency. The lighter green comes through as the color of the bottom of the ocean, and the darker tones represent the shadows cast by the rocks on the sandy bottom.

10 The application of dark blue and green brush strokes over the previous colors produces the effect of reflections on water illuminated by a radiant sun (a water with saturated and bright colors). The brush strokes become darker as they get closer to the shore.

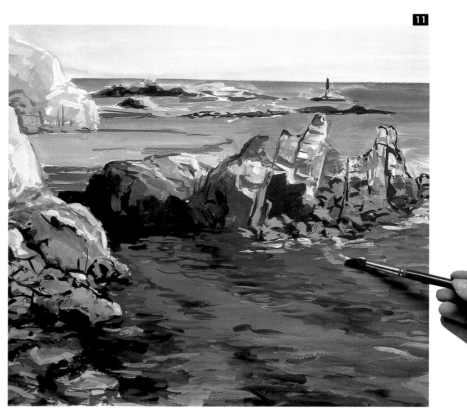

11 Because gouache has good covering power, layers of white paint can be applied over the previous colors to represent the foam of the waves breaking against the rocks.

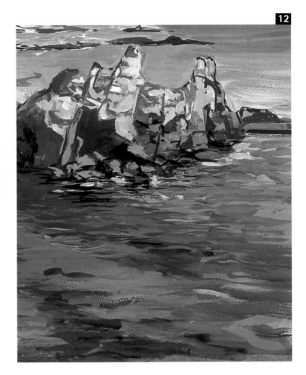

HALFTONES
Between the lighter colors of the rocks (ochre, gray lightened with white) and the darker ones (purple darkened with black) there is a rich range of earthy and green tones that hold together extremes of light and shadow. Many halftones are required for the effect of luminosity to be convincing; otherwise, the chiaroscuro would look too abrupt and unreal.

12 There are only a few touches left to finish defining some areas of the rocks in more detail. The transparencies, as well as the reflections, have been masterfully represented.

13 The final details are applied to the distant rocks, the definition of which makes it possible to round out the effect of transparency, which was the goal of this exercise painted by Myriam Ferrón.

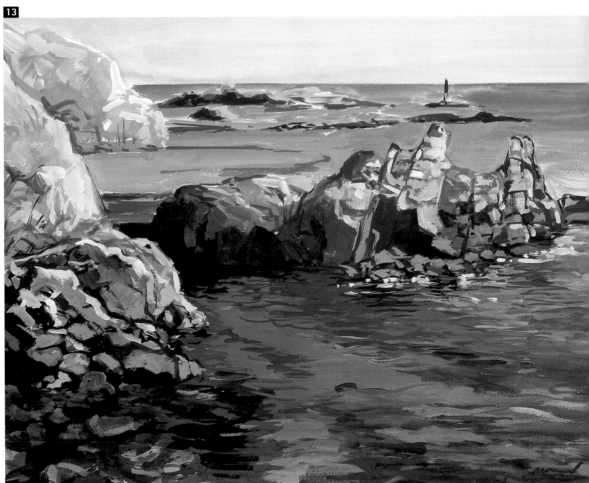

Waves at the Beach

Long coastal lines of sandy beaches are usually a difficult subject for a seascape artist to represent. The difficulty stems from the monotony of the lines and the colors. Oftentimes, everything is reduced to a lower strip that represents the sand, an intermediate band for the sea, and an upper one for the sky. But in this case, the sky is particularly interesting, the sea is lined with waves, and a cliff frames the beach.

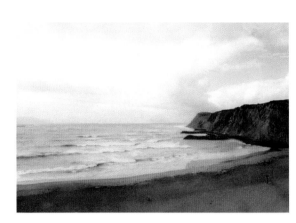

This shows a part of the coast where the elements are the protagonists. The raw colors are slightly softened by the gray light. Notice how the waves, which add interest to this landscape, will be painted.

TECHNIQUES USED
◆ White reserves ◆
◆ Washes ◆
◆ Representing waves ◆

MATERIALS
- Medium-grain watercolor paper
- Assortment of watercolors
- One medium ox-hair round brush and one thin round sable-hair brush
- Flat, soft-hair brush
- White crayon
- Hard graphite pencil

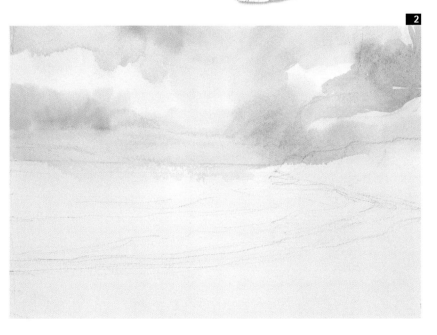

1 Using a hard pencil that makes a thin, light line, the basic outlines of the composition are laid out. The lines should be very light so they do not become too visible under the thin layer of watercolor.

2 The gauzy clouds that cover the sky are a wash of very diluted color: carmine, ultramarine blue, and a small amount of sienna to darken the color.

3

OVER WET AND OVER DRY
Painting with watercolors over wet (either wet color or wet paper) diffuses the tones and promotes the rapid expansion of the color. If the work is done over dry, the brush stroke holds its shape and the resulting color is more saturated and homogenous.

4

3 The edges between the areas of color are touched up with a thin brush, adding small amounts of paint over dry. This layering creates the effect of separation and distance that defines the masses of clouds.

4 This shows what the soft clouds look like. The slightly mauve layer of color includes an area in which the blue is more pure but whose intensity has been reduced to blend with the overall tonality.

5

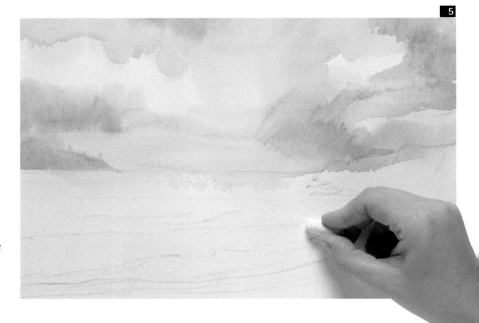

5 Now the crests of the waves are painted with a white wax crayon. This little trick prevents the paint from adhering to the areas drawn on with the crayon, and they will remain white until the end of the process.

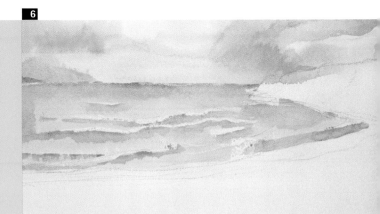

WHITE RESERVES

It is not uncommon for watercolor artists to reserve white areas of the paper by painting around them. These reserves will correspond to the white colors or to the lightest tones of the theme. At the end of the process, those pure whites can be touched up or shaded to prevent them from looking too harsh against the colors around them and creating too much contrast.

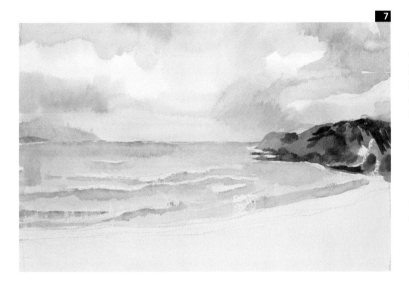

6 Here we can easily see how the tops of the waves remain white while the color for the sea has already been applied. This same effect could have been achieved without the crayon, but it would have involved more work.

7 The rocky area of the coast is painted with a cool color: blue mixed with carmine to which small amounts of ochre have been added.

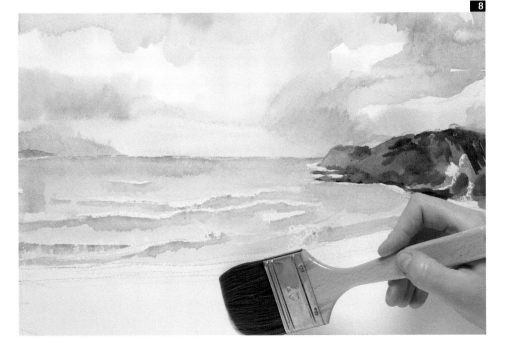

8 Before the strip of sand is painted, the entire area is moistened with a large, soft-hair brush in order to apply the color easily and without the need for many brush strokes.

9 It is easy to see that there are no brush marks on the strip of warm color (a mixture of yellow and carmine) that is the base color for the sand. This is because the color has been quickly brushed over the wetted paper.

10 While the paint in this area is still wet, more of the same color is applied, although this time it is a little bit darker because it has more carmine. Once again, there are no marks in this application, and the outlines of the resulting block of color are not clearly defined.

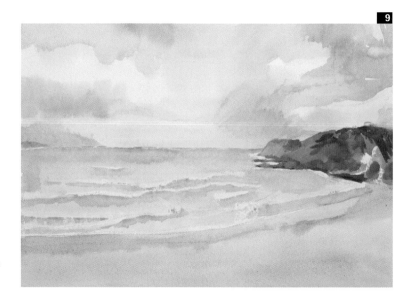

9

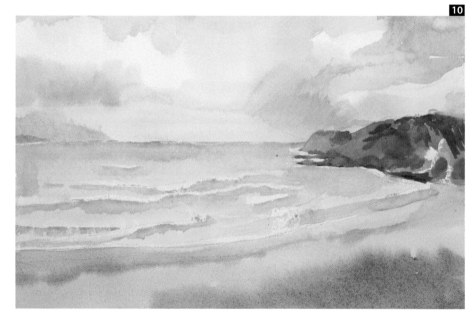

10

11 The surface of the beach was touched up when the color was almost dry, but there was still enough moisture on the surface to keep the brush marks from showing.

WASH BRUSHES
A wash brush is a wide, flat brush, similar in shape to its smaller counterparts. Some artists use them for watercolor paintings, although any brush can be used with this medium. The most suitable ones are soft-hair brushes, such as badger and sable, among others. The harder the hair the smaller the amount of water they can carry and the greater the risk of leaving brush marks on wet paper.

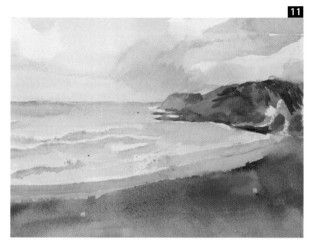

11

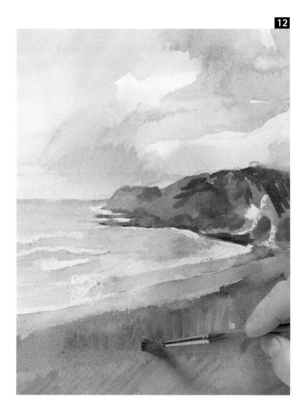

12

THE DISTANT BACKGROUND

Regardless of the type of landscape being painted, it is common practice to leave the distant areas (those farthest from the viewer) relatively undefined, to emphasize the perception of depth. This is especially recommended in paintings with a dense atmosphere such as this one.

12 A few parallel brush strokes of the same color as the base are applied to add detail to the foreground of the composition and to make it advance toward the viewer. Applying the brush strokes over a dry surface makes them quite visible.

13 This is the finished painting created by Mercedes Gaspar, after applying a simple and extremely effective process. The atmosphere of the seascape is wet and dense, thanks to the unity of the colors and to the work done on wet paper.

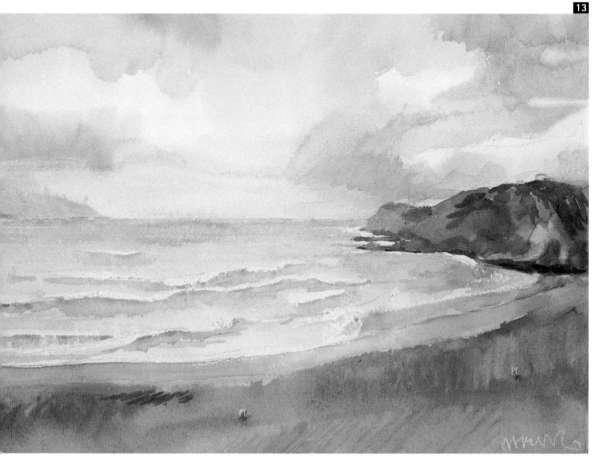

13

Highlights in the Water of the Bay

An evening over the calm waters of the bay: This is a scene where the light comes from behind, creating a huge reflection on the sea. The distance prevents the reflection of the light from being disturbed by the shadows of the waves, resulting in a great band of light that spreads across the entire inlet. The warm tonality has an effect on every color of the composition. This subject, painted by David Sanmiguel, gives us the opportunity to study a very unusual chromatic approach in seascapes.

MATERIALS
- Tan color, Canson paper
- An assortment of hard and soft pastels
- Eraser
- Cotton rag
- Soft graphite pencil

TECHNIQUES USED
♦ Representing highlights ♦
♦ Ochre tones on the water ♦

This spectacular image of a sunset over the port with the light coming from behind offers a superb opportunity to practice painting highlights made by the sun on tranquil water.

1 It is very important to establish the level of the horizon with a straight line that is centered on the paper, leaving enough space for both the band of water and for the sky. The outline of the horizon is sketched above that line.

2 The color of the paper provides the midtones (the intermediate color for the composition). The first applications of color are for the areas of the most light: the highlights of the water and the sun. These colors are spread with the fingers.

3

USING A RAG
Rags are very useful for spreading pastels and for wiping away the pigment, leaving the paper tinted but not saturated with color. This procedure is useful when the goal is to layer colors or if the artist wants to let the tone of the support come through when working with color paper. Also, rags make spreading pastels over large areas much easier than working them with the hands alone.

3 The sky has an ochre coloration that is tinted with raw sienna. The darker areas— that is, those farthest from the sunlight—are painted first, to reinforce the effect.

4 After applying raw umber and burnt sienna in a few areas, the color is spread with a rag over the darkest area of the sea. This tonality, similar to that of the sky, goes very well with the color of the paper.

4

5

5 The first applications of color have established the guidelines for the rest of the process. This will be a composition of great chromatic unity.

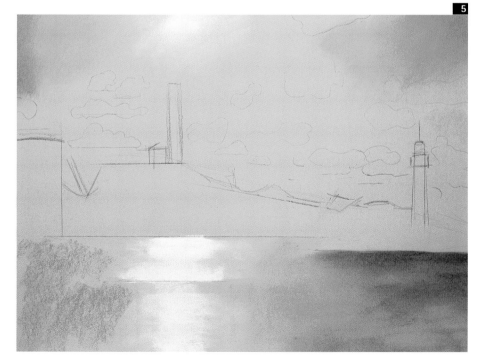

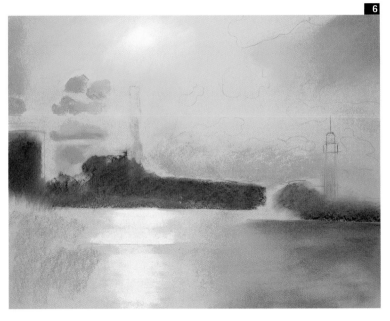

SOFT AND HARD PASTELS

Soft pastels are the most appropriate media for working with large and medium-size formats that require vast areas of color. Covering large areas with pastels using the fingers or a rag is very easy. Hard pastels are better for outlines and for figure drawing. The majority of pastel artists combine both kinds of mediums, reserving the hard type for enriching the color of certain details or for defining the outlines of specific shapes.

6 Now is the time to create the silhouette of the horizon. A dark earth tone (burnt sienna) is used for this. It is applied quickly, without worrying, for now, about the accuracy of the outlines.

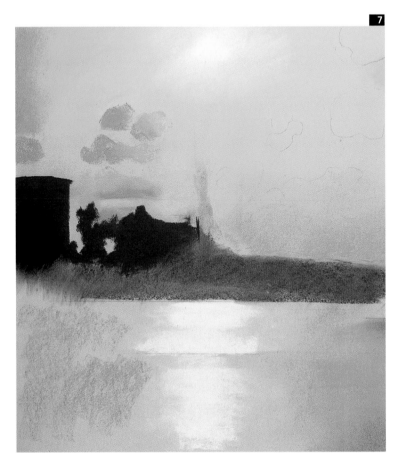

THE COLOR OF THE PAPER

Pastels can be used on color paper. But the color should be chosen according to the general tone of the work. In this case, the subject calls for tan, which is one of the most common colors used by pastel artists.

7 After a few small clouds have been painted with a very blended light blue, the outline of the edges of the horizon is detailed with a hard stick of pastel sepia.

8 The horizon must be drawn very carefully because its clean and proper definition will help create the effect of backlighting and enhance the atmospheric feeling of the painting.

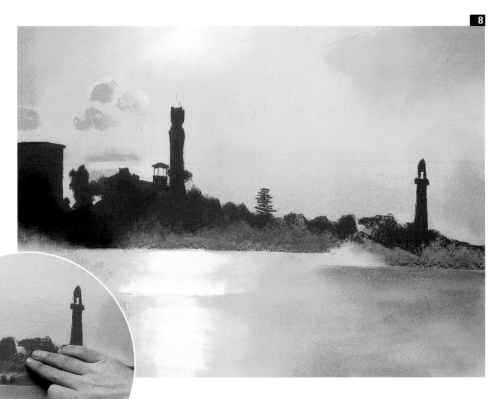

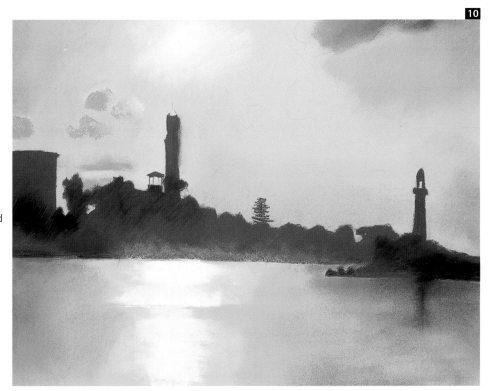

9 The lines made with hard pastels and blended colors created with soft pastels are combined in the dark shapes of the horizon. This layering provides considerable richness to the texture of this area of the composition.

10 The work has focused on creating the atmospheric effects in the sky. These effects are based on the coloration of the clouds, which are darker than the sky but of a very similar color in some areas.

11 The golden color of the water has been created by adding a small amount of light green to the overall ochre tone. Also, in this last phase of the work, the highlights of the water are reinforced with pure white strokes.

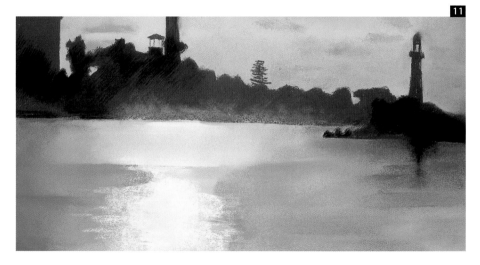

12 The result is a beautifully colored painting. The white highlights in the water have created a golden brightness that makes this an interesting subject for practicing seascape painting.

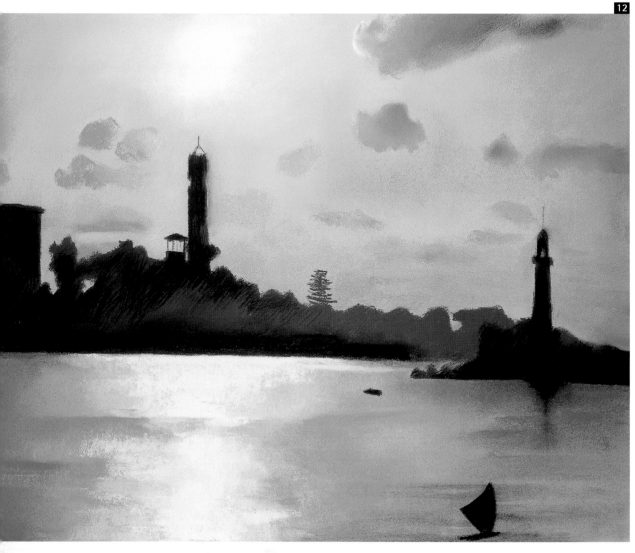

**Other Books about Water Effects
by the Publisher**

If you wish to study how to represent
water effects in more depth, you will find
practical applications of the techniques
explained in this book in the following
titles by **Barron's Educational Series, Inc.:**

*Easy Painting and Drawing: Painting
Various Subjects with Mixed Media*

*Pocket Reference Books: Painting
Waterscapes*

All About Techniques
– *Airbrush*
– *Color*
– *Drawing*
– *Illustration*
– *Oil*
– *Pastel*
– *Watercolor*

Art Handbooks
– *Acrylics*
– *Airbrush*
– *Charcoal, Sanguine Crayon, and Chalk*
– *Colored Pencils*
– *Oils*
– *Vegetation*
– *Watercolor*

Artist's Handbooks
– *Acrylics & Gouache*
– *Oil*
– *Pastels*
– *Watercolor*

Learning to Paint
– *Acrylics*
– *Oil*
– *Pastel*
– *Watercolor*

The Painter's Corner
– *Airbrush*
– *Landscape*
– *Oils*
– *Watercolor*